NORTH AMERICAN

INDIAN ARTS

A Golden SCIENCE Guide

by

ANDREW HUNTER WHITEFORD
Director, Logan Museum of Anthropology
Beloit College

Under the editorship of
HERBERT S. ZIM, Ph.D., Sc.D.

Illustrated by
OWEN VERNON SHAFFER

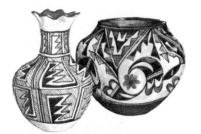

GOLDEN PRESS • NEW YORK
Western Publishing Company, Inc.
Racine, Wisconsin

FOREWORD

The purpose of this guide is to give recognition to the creativity and the productive skills of the North American Indians, to stimulate interest in their contemporary crafts, and to assist collectors and curators with the identification of specimens in their collections. This brief introduction to the material culture of the Indians cannot depict all their crafts or explain all the techniques they used. Some of the artifacts shown are ancient and are known only from archaeological excavations; most of them were still being made in this century, and a few are still being produced.

Most of the illustrations were made from actual specimens; the present locations of these specimens are indicated on the illustrations by letters following the picture numbers, each letter referring to a location listed on page 155. Many of the specimens are in the Logan Museum of Anthropology at Beloit College, and extensive use was made of the collections in the Field Museum of Natural History of Chicago and in the Milwaukee Public Museum. We are indebted to Donald Collier, Phillip Lewis, James Van Stone and Christopher Legge at the former, to Robert Ritzenthaler, Lee Parsons and Thomas Kehoe at the latter. I am grateful, also, for advice and information, to Charles Di Peso, Florence Ellis, Norman Feder, Don Watson, Clark Field, Jeanne Snodgrass, Tom Bahti, Frederick Dockstader, Sonia Bleeker Zim, Bernard Brown, Milford Chandler, James Griffin, Robert Salzer and Bill Holm. Much of the information here came originally from the late Frederic Douglas. Druscilla Freeman gave constant help with the materials from the Logan Museum, which are chiefly from the Horatio Rust, Bob Becker, Helen Green, Herbert and Sonia Zim, and Albert Heath collections. The book was possible only because of the skill, interest and patience of the artist, O. V. Shaffer, and the guidance of the editor, Herbert Zim.

A. H. W.

CONTENTS

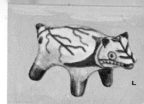

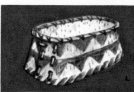

INTRODUCTION

THE ARTS OF THE NORTH AMERICAN INDIANS
attained a degree of sophistication and diversity
that is generally unrecognized. Some people
know the fine pottery of the Southwest but few
realize that the tribes of the Southeast and Gulf
areas made figurine bottles and decorated their
pots with complex stamping as well as painting,
engraving and incising. It is not generally known
that Indians of the Lakes area made some of the
first metal tools ever produced or that the Creeks
made elegant copper plaques embossed with
eagle designs. The silverwork of the Southwest is
known but not that of the Kiowa or the Iroquois.
Many people buy Navajo rugs but few know that
fine weaving was done on the Northwest Coast
or that the Lakes tribes made beautiful woven
bags and sashes without a loom.

Some of the arts of the Indians are unique.
Porcupine quills and moose hair were used for
embroidery in a manner unequaled in other parts
of the world and few people utilized bone, shell,
antler or bark with such skill. Some tribes chipped
and ground stone tools and ornaments as fine as
any ever made. Such accomplishments indicate
the understanding the Indians had about their
natural environment. They knew and respected
the resources of nature and used an endless va-
riety of raw materials to produce a variety of cul-
ture patterns, which have been greatly admired
but not truly appreciated.

L

4

THE ARTS OF A PEOPLE are the skills and techniques they employ in making and using their tools, implements and ornaments. They include the methods of gathering and preparing the raw materials; the processes by which they are converted into utilitarian, decorative or ceremonial objects; and the techniques of painting, carving, embroidering, or stamping used to decorate them. The making of almost any object requires knowledge of several arts and we speak of the art of weaving, the art of stone chipping, or the art of preparing leather.

The objects man makes are called artifacts, and every artifact, whether it is beautiful or ugly, crude or refined, utilitarian or ceremonial, is a reflection and product of man's skills, his techniques, his arts. Most societies of the world do not have a special group of things or activities which they call "art"; but today, because of increased contact between cultures, the beauty of non-European arts is recognized. The expression "fine arts" is something different. Some of the artifacts illustrated in this book are art objects but they are included here as examples of materials used, techniques employed and designs produced by particular tribes of American Indians. For this purpose the mundane is as important as the artistic. Artifacts were chosen as being typical rather than superior or extraordinary. This is not a book about art but about the arts reflected in the material culture of the North American Indians. (Key to present location of most of the artifacts illustrated in this book is found on page 155.)

L

5

MATERIAL CULTURE, the artifacts a people make and use, tells a great deal about the Indians. Each artifact is produced by a particular individual, large artifacts like canoes by a group. The materials used, the way an artifact is made, its final shape, the decoration which embellishes it, and the uses made of it are distinctive of the society or the tribe of the person who made it. Artifacts reflect the ideas, the concepts, and the knowledge acquired or learned as a member of a tribe. Members of a particular tribe use certain techniques, and create a particular style because that is their tradition.

No two Navajo rugs are exactly alike; every Apache basket is different yet each one is distinctly the product of one particular tribe. Weavers follow tradition even while experimenting and creating new patterns. This is why Iroquois masks are distinctly Iroquois. This is why Hopi in some villages make only wicker baskets while their neighbors make only coiled baskets. The artifacts of a people are material reflections of their mental concepts. Their artifacts also reflect contacts and exchange of ideas with other groups. Actual specimens often were traded or stolen and ideas were borrowed and adapted in new forms.

Knowledge of a people's arts provides one key to an understanding of their way of life. It is only when we understand and appreciate the arts that baskets, masks, rugs, pots and other artifacts become spokesmen for their creators instead of curios to be preserved only because they are strange, rare or lovely.

L

NORTHWEST COAST: conifer forests. Mild climate. Warrior fishermen; villages of large plank houses. Society based upon lineage and wealth; complex ceremonials; artistic development.

CALIFORNIA: conifers in north; desert in south; oaks in between. Moderate to hot climate. Conical or domed houses. Used acorns for food; also hunted.

SOUTHWEST: mountains and desert. Extremes of heat and cold. Intensive ceremonial life. Arts in weaving, basketry and silver. Two sub-areas: **Pueblo Farmers** in villages of multistoried apartments (farming, complex religion, and fine pottery); and **Circum-Pueblo Herders**, semi-nomadic tribes; single-family houses.

BASIN: mountains and desert. Extremes of heat and cold. Skin or brush one-family houses. Nomadic bands gathered seeds and roots; hunted; made fine baskets.

PLATEAU: mountains, hills and rivers. Extremes in climate. Semi-subterranean plank houses in villages; some nomadic hunting tribes. Fishing, gathering, woodworking; excellent baskets.

PLAINS: grasslands. Cold winters, hot summers. Nomadic tribes; camps of conical skin tipis. Horses for war and buffalo hunting. Skin- and featherwork, fine quill- and beadwork.

SOUTHEAST: mountains, forests and rivers. Hot summers, mild winters. Warlike tribes; palisaded villages. Farmed, hunted and fished. Complex political and ceremonial organization. Art in wood, shell, clay and copper.

PRAIRIE: short grass parkland; some deciduous forests. Winters cold in north; hot summers. Villages of multifamily earth lodges or bark houses. Corn and beans; seasonal buffalo hunts. Strong chiefs; important ceremonies. Pottery, baskets, finger-woven sashes and beadwork.

LAKES: forests and lakes. Cold winters; moderate summers. Semi-nomadic hunters and fishers; harvested wild rice. Village gardens except in north. Bark- and mat-covered wigwams. Simple tribal organization. Quill- and beadwork; bark, baskets and finger weaving.

NORTHEAST: deciduous forest in south, conifers in north. Cold winters, mild summers. Farms in south (corn and beans); hunting and fishing tribes in north. Palisaded villages, bark-covered houses. Fine work in bark, quills and beads; pottery and baskets.

SUBARCTIC: conifer forests and tundra. Cold winters, short summers. Nomadic groups hunted and fished; lived in conical bark or hide shelters. Crafts in bark, skin and wood.

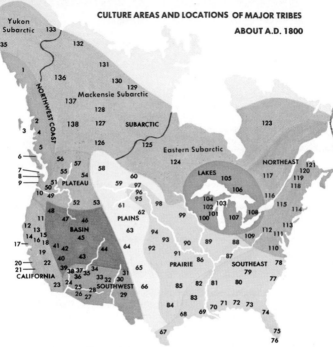

Yukon
Subarctic

NORTHWEST COAST

Mackensie Subarctic

SUBARCTIC

Eastern Subarctic

PLATEAU

LAKES

NORTHEAST

BASIN

PLAINS

CALIFORNIA

PRAIRIE

SOUTHEAST

SOUTHWEST

CULTURE AREAS distinguish those tribes which were similar to each other from those which were different. The areas tend to coincide with ecological zones but they blend into each other and never existed as real entities in the lives of the Indians.

By 1800 some tribes were already extinct and the major tribes of the Plains had just moved west and acquired horses. A short time later disease practically wiped out some of the large Prairie tribes and most of the Southeastern tribes were forced to move west across the Mississippi. Some tribes still live where they did.

NORTHWEST COAST

1. Tlingit
2. Tsimshian
3. Haida
4. Bellabella & Bellacoola
5. Kwakiutl
6. Nootka
7. Makah
8. Quileute
9. Quinault
10. Coast Salish

CALIFORNIA

11. Modoc
12. Yurok
13. Karok
14. Hupa
15. Shasta
16. Wintun
17. Pomo
18. Maidu
19. Miwok
20. Costano
21. Chumash
22. Yokuts
23. Mission

SOUTHWEST

24. Yuma
25. Maricopa
26. Papago
27. Pima
28. Chiricahua Apache
29. Mescalero Apache
30. Rio Grande Pueblos
31. Jicarilla Apache
32. Acoma Pueblo
33. Zuni Pueblo
34. Navajo
35. Hopi Pueblo
36. Yavapai
37. Havasupai
38. Walapai

BASIN

39. Chemehuevi (Paiute)
40. Mono
41. Washo
42. Panamint

43. Paiute
44. Ute
45. Gosiute
46. Bannock
47. Shoshoni
48. Paviotso

PLATEAU

49. Wishram
50. Klikitat
51. Yakima
52. Nez Percé
53. Flathead
54. Kutenai
55. Thompson
56. Lillooet
57. Shuswap

PLAINS

58. Blackfeet
59. Gros Ventre
60. Assiniboin
61. Crow
62. Teton Sioux
63. Cheyenne
64. Arapaho
65. Kiowa
66. Comanche

SOUTHEAST

67. Tonkowa
68. Atakapa
69. Chitimacha
70. Natchez
71. Choctaw
72. Alabamu
73. Apalachee
74. Timucua
75. Calusa
76. Seminole
77. Catawba
78. Tuscarora
79. Cherokee
80. Creek
81. Chickasaw
82. Quapaw
83. Caddo

PRAIRIE

84. Wichita
85. Kansa
86. Missouri
87. Shawnee
88. Miami
89. Illinois

90. Ioway
91. Oto
92. Pawnee
93. Omaha
94. Ponca
95. Arikara
96. Mandan
97. Hidatsa
98. Yankton
99. Santee

LAKES

100. Kickapoo
101. Fox
102. Sauk
103. Winnebago
104. Menomini
105. Chippewa
106. Ottawa
107. Pottawatomi
108. Neutral

NORTHEAST

109. Erie
110. Powhatan
111. Nanticoke
112. Conestoga
113. Delaware
114. Mahican
115. Iroquois
116. Huron
117. Algonkian
118. Abnaki
119. Penobscot
120. Malecite
121. Micmac
122. Beothuk

SUBARCTIC

123. Naskapi
124. Cree
125. Chipewyan
126. Sarcee
127. Beaver
128. Slave
129. Yellowknife
130. Dogrib
131. Satudene
132. Hare
133. Kutchin
134. Ingalik
135. Tanaina
136. Kaska
137. Sekani
138. Carrier

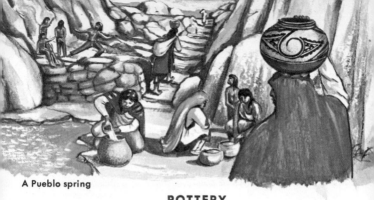

A Pueblo spring

POTTERY

Pottery was made by many tribes of the Southwest and in central and eastern North America and by some of the Indians of the Prairies and the Plains also. Most pottery was made originally for cooking and other mundane purposes but many pots were decorated beautifully. In California and on the Northwest Coast baskets and wooden containers took the place of pottery.

All pottery is made from clay. Indians used various techniques, but none had the potter's wheel, although in the Old World it was known since ancient times. Pottery reflects the tastes and talents of its makers, since it can be molded into nearly any shape. It can be decorated by many techniques and varied designs. Each group made a distinctive type of pottery.

Pots break easily but the sherds, or pieces, last for centuries. They help archaeologists date ancient cultures. The earliest North American pottery was made about 2000 B.C. in the east, and about 300 B.C. in the Southwest.

Pot sherds

PREPARING THE CLAY requires several steps. The potter, generally a woman, often travels considerable distances to get fine clay from highly prized deposits. But even the best clay must be pulverized before it can be used. The potter crushes the lumps with a stone, hammer, or wooden club. Potters in the Southwest grind the clay to a fine powder with a mano and metate, like those used to grind corn.

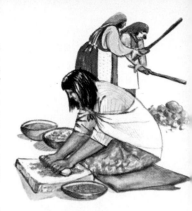

CLEANING THE CLAY removes lumps, fragments and small pebbles which would spoil the pottery. These are removed by repeatedly sifting or tossing the pulverized clay in a winnowing basket. Lumps or pebbles drop back into the basket, while the fine clay is blown onto a blanket, spread out downwind. Now the clay, fine and smooth as flour, is ready for the potter. It is usually stored dry until she is ready to begin making pots.

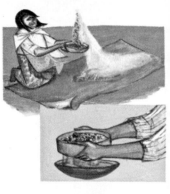

WETTING AND TEMPERING THE CLAY is the final step in getting it ready for use. The potter adds water and kneads wet clay on a skin or flat stone until it is like dough or putty. As she works she adds a finely crushed tempering material: limestone, shell, sand, sherds, or even plant fibers. The proper amount of added temper prevents the pots from cracking during drying and firing. Too much temper makes the clay gritty and difficult to work.

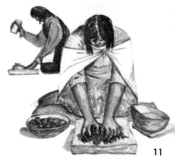

POTTERY MAKING by North American Indians is done by two basic techniques: coiling (below) and modeling and paddling (p. 13). These are often combined. Both

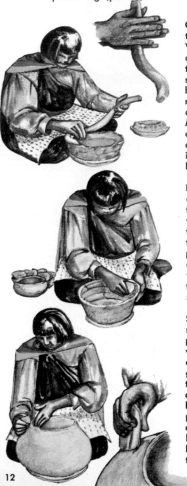

COILING is the ancient way that Pueblos still make pottery. With wet hands the potter pats clay into a pancake the size of the bottom of the pot. This is set inside a shallow bowl or basket. A thick coil of clay is rolled out and carefully laid around the rim of the pancake. More coils are added, one above the other and slightly overlapping. Each coiled layer is firmly pinched to the layer beneath to make it adhere.

BUILDING THE POT starts as coils spiral upward, one above the other. The potter squeezes them between her thumbs and fingers. This thins the coils to the thickness of the finished pot. The cracks between the coils are smoothed out as she turns the pot. As the walls rise, the potter smoothes them and slopes them inward or outward.

SHAPING THE POT goes slowly, so the potter works on several pots at the same time. The walls must dry as they are curved. Using curved pieces of gourd, shell, or sherd, the potter smoothes the inside and outside, curving the wall against her left hand held inside the pot. A small bowl is shaped in one sitting, but the base of large water jars or ollas must be set aside to harden before the top is added.

start with wet, tempered clay. After the pot is built, the drying, polishing, decorating, and firing are basically the same for both techniques.

MODELING AND PADDLING is a technique used by the Cherokee and other eastern tribes. It is still used by the Papago and Yuma of Arizona. A large clay pancake is laid over the bottom of an inverted jar, which serves as a mold. The potter turns the mold as she pats the clay, thinning and spreading it into an even layer. First she uses a smooth, flat stone, then a curved wood paddle.

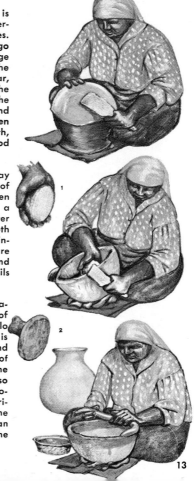

SHAPING begins after the clay has been spread over a third of the mold and allowed to harden slightly. Then it is placed on a ring of fiber and the potter paddles it, holding a smooth anvil stone (1) against the inside wall. As the walls are beaten, they are thinned and evened. In the east, clay anvils (2) were used.

FINISHING a deep bowl or water jar requires the addition of a number of coils as in Pueblo coiling. However, the surface is worked with the paddle and anvil, which thins the walls of the pot and obliterates the coils. This technique was also used by the prehistoric Hohokam Indians of southern Arizona—possible ancestors of the Papago—and by the Mandan and other village tribes of the Prairie area.

13

SMOOTHING begins after the jar has dried in the sun for a day or two. If it has not cracked badly, the surface is wet with a cloth and scraped smooth with a kitchen knife or scraper. A flint chip or a piece of bone was once used. Any cracks or holes are filled with wet clay and the surface is rubbed with a dry corncob or a piece of sandstone. After a final wiping with a wet cloth, plain utility pots are fired.

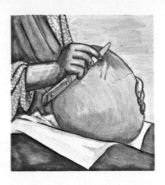

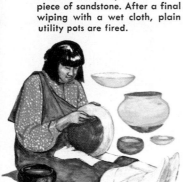

SLIPPING is necessary on pots which will be decorated. The slip is a creamy mixture of water and colored clay (white, tan, yellow, or red). Several coats are applied to the jar with a rag or a rabbit tail. The slip fills the pores and gives the pot an even color and a smooth base for painting. Between coats the pot is set out to dry. Slip is also applied to the inside surfaces of wide or shallow bowls and on edges of flaring rims.

POLISHING a pot takes hours. Pots are polished by rubbing with a small, smooth stone before the slip is quite dry. These fine-grained polishing stones are heirlooms, passed from mother to daughter. The lustrous red and black Pueblo pottery is given its shiny finish by hard polishing, and rubbing with fat. Vessels to be painted get little or no polishing. The art of glazing was never mastered, so pots are never completely waterproof.

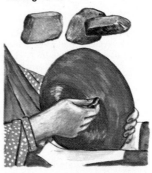

FIRING POTTERY is tricky. Large jars must be fired separately. Smaller pots are fired several at a time. To heat the pots evenly, they are inverted on rocks, on cans, or on a metal grill. A fire is built under them. Dried cakes of sheep or cow dung—which burn evenly and slowly—are piled over the pots. Since contact with the burning fuel stains the finish, pots are covered with large pieces of sherds or with galvanized iron.

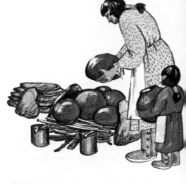

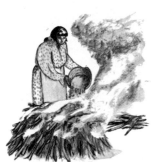

SMUDGING is achieved by smothering the fire with fine, damp manure. This "closed" fire with little draft produces a dense smoke, which impregnates the pottery with carbon and gives it a black, shiny finish.

An "open" fire, on the other hand, permits air to reach the pots and turns the clay and mineral paint red. The change in color is permanent.. Firing and smudging take 30 minutes to several hours.

WIPING is done immediately after firing to minimize or reduce discoloration. Overfiring or underfiring can spoil the pots, causing flaking, discoloration, or an uneven finish. The potter may remove the pots from the fire when she thinks they are ready, or she may let the fire burn out and leave the pots there. After they have been removed and cooled, they are rubbed with a slightly greasy cloth or chamois to produce a sheen.

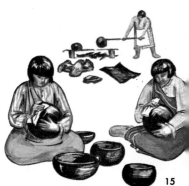

15

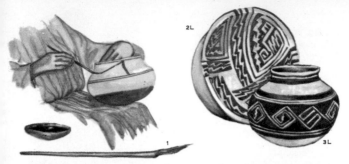

DECORATING

DECORATING is done by varied techniques and in many designs. The pottery in each area, as shown on the following pages, has its own characteristic designs.

PAINTING is still widely used to decorate pots in the Southwest. Potters make no measurements or sketches but paint designs free-hand. They use ground minerals and boiled plant juices. The Papago paint with a stick; the Pueblo use a feather or a brush of yucca (1). The potter chews the ends of a split yucca leaf, then trims the remaining fibers to size.

NEGATIVE DESIGNS are produced by a reverse process. Instead of painting the design, the potter paints the background black leaving the design in the color of the original base slip. The finest negative designs were made in the Kayenta region of northern Arizona. These black painted backgrounds created contrasting geometric patterns (2, 3).

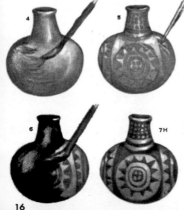

NEGATIVE OR RESIST PAINTING, developed in the prehistoric cultures of the Central Region, is a stencil technique. A surface is colored, but certain areas (shielded by a temporary wax cover) are not affected. A cream slipped bottle is covered with a coating of wax or clay (4). A design is scraped through the wax exposing the slip (5). The entire bottle is then painted black (6). The black paint adheres to the slip to form a design when the remaining wax is removed (7).

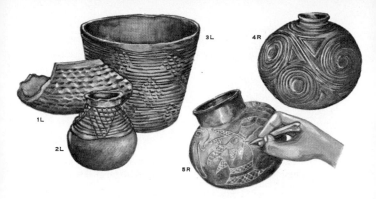

CORRUGATION is produced when a potter smoothes a pot on the inside, but leaves the ridges of the coils on the outside. It was a technique commonly used in the prehistoric Southwest.

The potter often produced a scalloped effect in the walls of the pot by pinching the coils as they were applied (1). Designs were also created by incising (2) or by smoothing patterns into the exposed coiled surface (3).

IMPRESSING designs with shell, reeds, nets, cord, and fingernails in the soft clay of a pot was also a favorite technique, especially among eastern tribes.

Punctations were made by poking a pattern of holes in the clay (6-Gulf Coast). Simple cord-marking (7-Missouri) was widespread. From the east coast to the upper Missouri surfaces were impressed with cord wrapped around wood paddles (8) or sticks (9). Net and fabric marks are found on large shallow basins (10).

INCISING or scratching designs are done with a wood or bone tool in the soft clay of an unfired pot. Creek and Shawnee bowls have designs incised around the rims; Caddo bottles have incised spirals (4).

ENGRAVING usually makes finer lines scratched into the hard surfaces of pots after firing. Designs were engraved on fine black ware (5) in the Southeast.

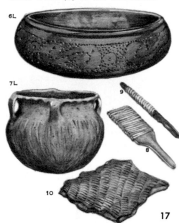

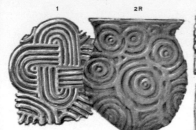

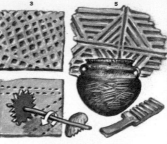

STAMPING was developed from impressing techniques. Designs are pressed into the clay while it is still soft. The Simple Stamp (6-Hidatsa), Florida to North Dakota, is a pattern of parallel grooves made with a carved or thong-wrapped paddle. Complicated stamp designs, an old technique in the Southeast, continued into the 19th century among the Creek and Cherokee. These often overlapped and were made by repeating fylfot crosses (1), concentric circles (2-Georgia), and diamonds (5).

Check Stamp (3) is an ancient and widespread decoration. Dentate Stamp, common in the north, was done with a notched shell-edge or by rouletting (4) to make rows of angular punctations.

EFFIGY MODELING was most common among the prehistoric tribes of the Central Region. They turned out jars in human form (p. 22), also large erect owls (7), bears, and raccoons. Bowls had bird, animal, or human heads on their rims (8) or were modeled with fish or frog features (9).

Effigy figures were also modeled in the Southwest during prehistoric times. The modern Zuni still make owls (10). Plumed snakes are carved on polished bowls at San Ildefonso and Santa Clara (11). A variety of painted figures is made at Cochiti (12) and polished black ones at Santa Clara (13). Pottery pipes were common. In the north, the Iroquois effigy forms (14) were outstanding.

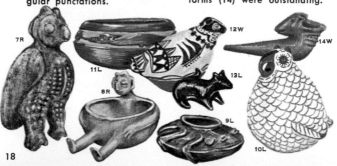

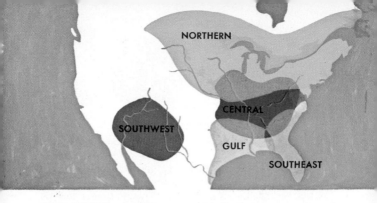

FIVE BASIC POTTERY REGIONS are recognized. The Southwest was almost independent because few other pottery-making tribes lived nearby. The other four regions overlapped in time and space and, at their boundaries, influenced one another strongly.

THE NORTHERN REGION (p. 20) saw the development of textile-impressed and cord-marked pottery, carried by early hunting and food-gathering tribes over most of the east and north, as far west as the northern Plains. These types may reflect influence from northern Asia. Early examples date about 1000 B.C. A century later, corn farming increased, permanent villages formed, elaborate burial complexes developed and new types of pottery were created.

THE SOUTHEAST (p. 21) is the region in which the earliest dated pottery, made almost 4,000 years ago, occurs. This was the home of Check and Complicated Stamp decorations, which the Creek, Cherokee, and other tribes made until recently.

THE CENTRAL REGION (p. 22), home of the Middle Mississippi corn farmers, adopted temple-mound building, as well as effigy pottery, painting, and incising from the neighboring Gulf Region. Between 1300 and 1700, they produced a rich culture extending from the Gulf Region to the Plains.

THE GULF REGION (p. 23) was influenced by eastern Mexico, stimulating an early development of large mounds surmounted by simple temples. Many styles of pottery were made. The early historic tribes of the region decorated their pottery with incised designs.

THE SOUTHWEST (pp. 24-32) is the most important pottery region in North America today.

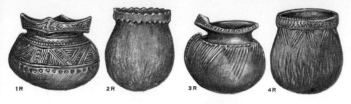

THE NORTHERN REGION

1. IROQUOIS, Onondagg-Oneida type. Angular incising is prominent on collared rim and shoulder (1350-1875).

2. IROQUOIS, Seneca type, cord-marked body and notched rim (1350 to historic period).

3. HURON, S. Ontario. Identified by single castellation on rim, incised decoration on body (1400-1649).

4. DELAWARE, Munsee type; N. J. Angular designs were made with cord-wrapped stick (to 1750).

5. ERIE, from W. Ohio to S. Mich. Designs were characterized by notched rim and cord-marked body (to 1654).

6. FOX. Angular punctation on lip, incised decoration (prehistoric in Mich.; 1650-1730 in Wis.).

7. ASSINIBOINE and/or CHIPPEWA, N. Minn, S. Man, W. Ont. Blackduck ware: cord-wrapped stick marks on neck, lip (950-1650)

8. MANDAN, N. Dak. Design on body is vertical Simple Stamp; S-shaped rim elaborately decorated with cord marks (to 1840).

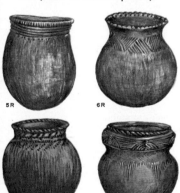

9. ARIKARA, S. Dak. Rim simple; handles decorated with cord-impressed designs; body is Simple Stamped (1450-1800).

10. SHOSHONI, Wyo. Undecorated flat-bottomed pots; also made by Blackfeet, Sarcee, and others (to 1850).

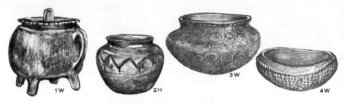

THE SOUTHEAST REGION

1. PAMUNKEY, Va. Shapes and finish are not traditional. Were made especially to sell to white trade (to 1890).

2. CATAWBA, N.C. Traditional design is characteristic but often modified by contact with whites (1908).

3. CHEROKEE, Tenn.-N.C. Complicated Stamp design illustrated here is very old in S.E. (to about 1890).

4. CHEROKEE, Tenn.-N.C. Check Stamp pottery was also made by Creek and other tribes (to 1750).

5. LOWER CREEK, Ga. Complicated Stamp ware decorated with prehistoric designs (1600-1700).

6. LOWER CREEK, Ga. and Ala. Incised designs on shouldered bowl with sloping rim; shape typical (1500-1800).

7. LOWER CREEK, Ga., Ala., Okla. Pot is roughened by brushing with grass stems; rough texture is common in S.E. (to 1890).

8. APALACHEE, N.W. Fla. Incised and modeled bowls were used to cover large burial urns (to 1704).

9. SEMINOLE, Fla. and Okla. Plain and brushed pottery were typical and were made in both areas (1750-1850).

10. TIMUCUA, N. Fla. Pottery similar to Creek; plain brushed, Simple and Check Stamp (to 1736).

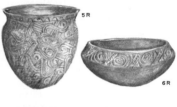

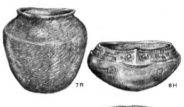

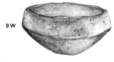

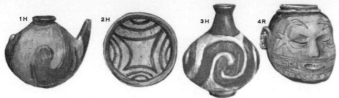

1H 2H 3H 4R

THE CENTRAL REGION

1. QUAPAW, E. Ark. The "teapot" shape was made throughout this area (1550-1725).

2. QUAPAW, Carson Red-on-Buff ware, crudely painted but distinctive geometric designs.

3. QUAPAW. This Red-on-White ware is considered to be one of the finest types of painted pottery.

4. MIDDLE MISSISSIPPI CULTURE, Ark. "Headpots", with facial painting, probably represent trophy heads (1400-1700).

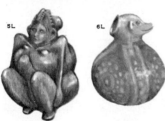

5L 6L

5. MIDDLE MISSISSIPPI CULTURE, Mo. Hunchback female effigy bottles were widely made during this period (1400-1700).

6. MIDDLE MISSISSIPPI CULTURE, Mo. Animal effigy bottle decorated with polychrome negative painting.

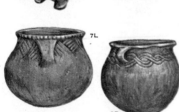

7L 8R

7. UPPER CREEK, Tenn., N. Ala. Large incised jars were very common in this region during this period (1400-1700).

8. SHAWNEE, Ohio. Pots were strap-handled and decorated with incised designs. Fort Ancient Culture (1400-1650).

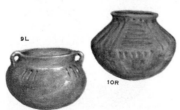

9L 10R

9. MISSOURI, lower Mo. Valley. Pottery is similar to that of Oto, Ioway, and Osage. Typical of the Oneota Culture (1400-1800).

10. WINNEBAGO, Wis. Squat jars decorated with broad incised lines. Oneota Culture (1400-1700).

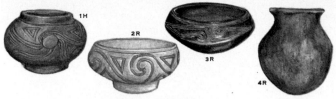

THE GULF REGION

1. NATCHEZ, lower Miss. Valley. Ring base; curving bands of incised parallel lines (1650-1730).

2. NATCHEZ. Painted bands outlined with incised lines. This design is widespread but at the same time rare.

3. CHOCTAW, Miss. Combed parallel lines, incised. Made in Okla. after removal from S.E. (to 1860).

4. CHOCTAW. These plain, shell-tempered pots were brought to Okla. from Miss. in the 1830's.

5. CADDO, Ark., La., Tex. High rims, incised designs. Similar designs were also made by the Quapaw (1300-1700).

6. CADDO. Curving patterns of broad incised parallel lines. Designs similar to Natchez and Quapaw.

7. CADDO. Angle-shouldered bowls typical of the Caddo area; rim and shoulders were decorated with incising.

8. CADDO. Typical bulbous bottle. White or colored pigment rubbed into the engraved decorations.

9. CADDO. Designs such as these were engraved and scraped through the hard, red polished surface.

10. CHICKASAW, N. Miss. Smooth finish. Rims decorated with incised designs or notched fillet (to 1850).

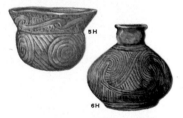

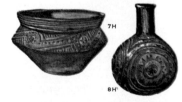

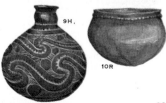

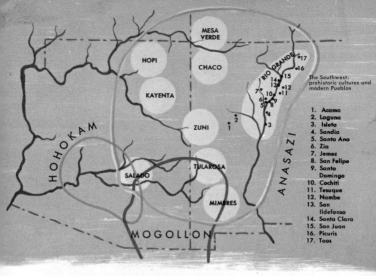

The Southwest: prehistoric cultures and modern Pueblos

1. Acoma
2. Laguna
3. Isleta
4. Sandia
5. Santa Ana
6. Zia
7. Jemez
8. San Felipe
9. Santo Domingo
10. Cochiti
11. Tesuque
12. Nambe
13. San Ildefonso
14. Santa Clara
15. San Juan
16. Picuris
17. Taos

SOUTHWEST POTTERY REGION

The Southwest is the only area where pottery is still made in the traditional way (pp. 28-32). The Hopi villages, Acoma, Zuni, and the Pueblo villages along the Rio Grande produce fine pottery decorated with new and ancient motifs. Each village has distinctive designs, new styles are created, and rarely are two pots alike.

THREE MAJOR PREHISTORIC CULTURES lived in this region: Mogollon (red): Hohokam (blue), which preceded the Pima and Papago; and Anasazi (green).

■**MOGOLLON CULTURE** (100 B.C.- 1400) began with the Cochise Culture (5000 B.C.) and acquired agriculture and pottery from Mexico. The first pots of these pit-house farmers were brown or red. Most of the later developments in the Southwest started here.

■**HOHOKAM CULTURE** (100 B.C.- 1400) was first influenced by Mogollon. It developed irrigation canal systems in the southern Arizona desert. Crafts included red-on-buff pottery, copper bells, figurines, textiles, and fine stonework; developed from contacts with Mexico.

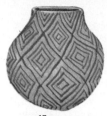

1F

2L

1. MOGOLLON San Francisco Red-on-Brown. (700-900).

2. MOGOLLON Three Circle Red-on-White (900-1000).

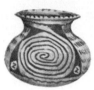

3R

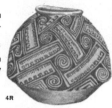

4R

3. HOHOKAM Santa Cruz Red-on-Buff, Colonial Period (500-900).

4. HOHOKAM Sacaton Red-on-Buff, Sedentary Period (900-1100).

■ **ANASAZI**, a Navajo word meaning "the old ones," is the culture which began with the Basketmakers (100-700) and developed into the modern Pueblos (1540 to present). Between 500-700 the early farmers first learned to make pottery.

During the Developmental-Pueblo Period (700-1050) masonry homes replaced pit houses. Chaco, Mesa Verde, and Kayenta, made black-on-white slipped pottery.

In the Great-Pueblo Period (1050-1300) large towns with fine masonry apartments were built. These were abandoned after 1276, when drought forced the people to move south to Hopi, Zuni, and Rio Grande Pueblos.

The Regressive-Pueblo Period (1300-1700) saw instability and Spanish occupation (after 1540). Glaze painting and polychrome replaced black-on-white.

● **MODIFIED-BASKETMAKER PERIOD** (500-700). Lino Black-on-Gray (5): unslipped. Lino Gray (6): coarse, thin, neck-banded. Abajo Red-on-Orange (7) shows influence from Mogollon.

5L

6L

7F

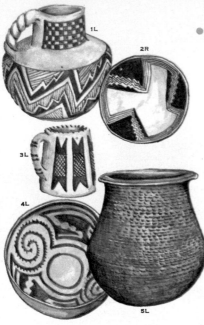

● **DEVELOPMENTAL - PUEBLO PERIOD (700-1050).** Slipped black-on-white pottery with painted designs showed artistry and imagination. Fine corrugated ware also made.

RESERVE Black-on-White (1). Hatched designs typical. Tularosa area.

WHITE MOUND Black-on-White (2). An early pottery type. Chaco area.

MANCOS Black-on-White (3). Mugs continue into next period. Mesa Verde.

BLACK MESA Black-on-White (4). Solid interlocking designs. Kayenta.

CORRUGATED (5). Fine spiral coil, unslipped. Used for cooking and storage. Mimbres area.

● **GREAT-PUEBLO PERIOD (1050-1300).** Pottery was thin, hard, often polished. Regional variations in decoration and shape make identification possible.

SAGI Black-on-White (6). Negative designs typical. Kayenta area.

Polychrome pottery made its first appearance in this period. Complex designs and excellent craftsmanship are characteristic.

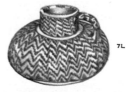

MESA VERDE Black-on-White (7). Soft black on pearly white slip.

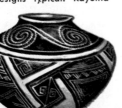

REGRESSIVE-PUEBLO PERIOD (1300-1700). After the Relocation (1270-1300) black-on-white and corrugated declined. Mineral glaze paints and new polychromes developed.

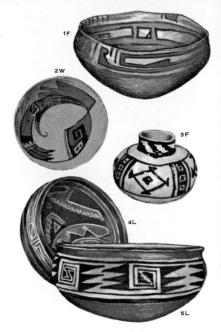

PECOS Polychrome Glaze (1). Mineral glaze paint. Prehistoric Zuni.

SIKYATKI Polychrome (2). Asymmetric designs. Prehistoric Hopi.

ZUNI Black-on-White Glaze (3). Designs in shiny mineral paint.

FOUR-MILE Polychrome (4). Bold asymmetric designs. Gila-Salt R. Salado area.

GILA Polychrome (5). Massive geometric designs. Salado area.

CHACO Black-on-White (6). Fineline hatching with polished finish.

TULAROSA Black-on-White (8). Hatched and solid spirals.

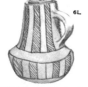

MIMBRES Naturalistic (7). Life forms; also polychrome and geometric.

ST. JOHN'S Polychrome (9). Bowls widely traded. Tularosa area.

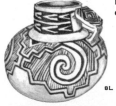

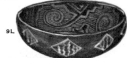

27

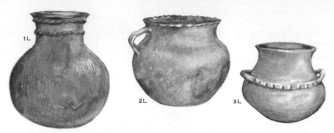

MODERN POTTERY in the Southwest is made chiefly in the Pueblo villages. Other tribes, such as the Papago, Maricopa, Mohave and Navajo, also make wares that are equally distinctive.

TAOS AND PICURIS make only unpainted gold-tan pottery which glitters with specks of mica. Some pots have blue-black smoke smudges. Jars (1) are common; also bean pots (2) which often have covers and loop handles, scalloped rims and notched fillets (3).

TESUQUE formerly made gray-cream pottery with frets (4) or stylized plants (5) in black. Now garish commercial colors are used on "tourist" wares (6).

SANDIA, JEMEZ, SAN FELIPE, NAMBE and **ISLETA** pueblos now have very few potters. The traditional pottery is practically extinct but some new types are being developed.

COCHITI makes creamy-yellow or pinkish pottery decorated with black designs of plants (7), birds, checkered fields, rain clouds and lightning (8, 9). The paint is often sloppily applied. Figurines of men and animals (p. 18) are still common.

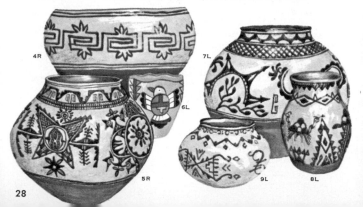

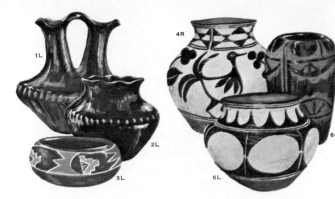

SANTA CLARA has plain polished black ware, often bluish-black with polishing marks. Flared rims and impressed designs are common on wedding jars (1) and pots (2). Polished red ware (3) is new.

SANTO DOMINGO uses a smooth cream slip, decorated with large birds and plants (4) or geometric patterns (5) with a touch of red. A recent ware has dull black design on polished black (6).

SAN ILDEFONSO makes many wares. Here, in 1919, Maria and Julian Martínez first used dull black paint on polished black ware (7). Carved designs began in 1931 (p. 18); white-on-red or white-on-pink (8) more recently. Older is a black-on-cream ware with touches of lavender-red to make polychrome (9). A black-and-orange buff ware with geometric motifs and fancy animals (10) is old but is still produced. Older yet is a fine polished black-on-red (11).

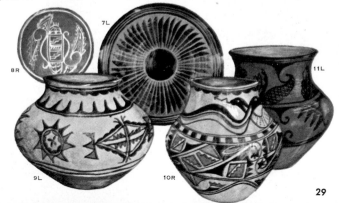

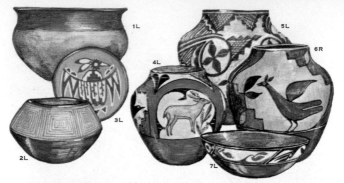

SAN JUAN favors polished red for upper parts with the lower part an unslipped tan (1). Recent wares have incised lines (2) and are sometimes red or pink painted on buff (3).

ACOMA pottery is thin and hard with white to yellow-brown slip. Geometric motifs (8, 11) and parrot-like birds (9) in overall designs are typical. Bases are traditionally dark red or brown. Modern potters copy prehistoric designs (10).

ZIA slips are white or yellow-buff with varied designs in black, red, or yellow: naturalistic deer (4), spirals enclosing leaf sprays (5), slender stylized birds (6). Bowls have plain red slipped interiors (7). Bases are red and broken edges show a brick red core.

SANTA ANA no longer makes pottery. Pottery made formerly was distinguished for its massive red designs, outlined in black, on a gray-white slip (12).

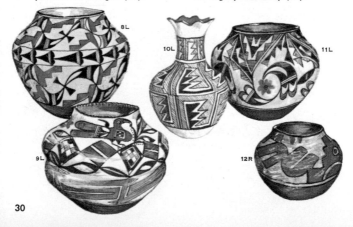

ZUNI pottery is distinguished by its chalk-white slip and the large designs painted in brown-black with touches of bright red, as shown on this large bowl (1). Brushwork tends to be casual.

Principal motifs are large scrolls edged with triangles (2), large rosettes with scalloped edges (3) and deer with white rumps and red "heart lines" (3, 6). Frogs, which are sometimes modeled in relief (4), tadpoles (6), dragonflies and other rain symbols are common.

On jars, the band around the neck carries a pattern which is different from the body. Bowls, especially those used for ceremonies, often have stepped or terraced rims (5, 6). The painted owl figures (p. 18), are still made for sale.

HOPI pottery was revived about 1900. Nampeyo, a woman of Hano on the First Mesa, copied fine pottery dug up in a prehistoric Hopi ruin. Potters developed a ware resembling the ancient Sikyatki (p. 27) with black, orange and white designs. The slip is cream-yellow, white, orange or dark-red. Motifs usually show highly conventionalized birds (7, 8, 10, 11), kachinas or masks (9). Major shapes are tall vases (7, 11), squat jars (8), round canteens (10), low bowls (12).

Hopi ware is thick, porous and has a dull, wooden sound. It is well formed, smooth, and polished. The villages on First Mesa make all decorated ware; the others make utility ware.

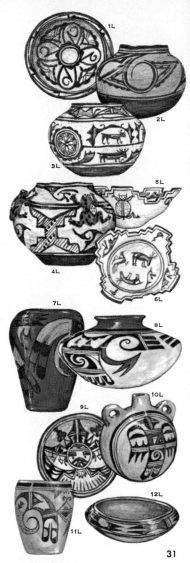

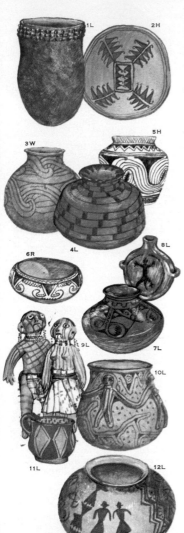

NAVAJO cooking pots are scraped with a corncob, lined with pinyon gum, and decorated with a twisted or indented band of clay (1). Painted pots (2) are very rare and relatively crude; were used chiefly in ceremonies.

PIMA AND PAPAGO, desert farmers of S. Ariz., who may be descendants of the Hohokam (pp. 24-25), produce jars decorated with red designs on unslipped buff (3). They also make smooth red ware with black decorations (4). Some modern pottery is made for sale and is known for its black designs on a white slip (5).

MARICOPA Black-on-Cream pottery (6) is made to sell. The old, traditional ware is highly polished red or orange decorated with geometric (8) and, more rarely, animal (7) designs in jet black paint.

YUMA AND MOHAVE, tribes of the lower Colorado, made pottery dolls decorated with beads and cloth (9) for toys and to sell to tourists. They also made pots decorated with relief figures (10) and red paint. Designs were geometric (11) motifs interspersed with dots.

SOUTHERN CALIFORNIA pottery was similar to that of the desert people of southern Arizona, above. Diegueño, Kamia, and other Mission tribes made buff pottery, decorated with simple red designs (12).

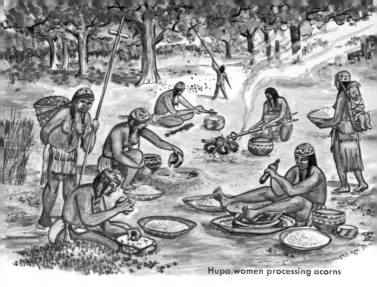

Hupa women processing acorns

BASKETS

Indians first made baskets at least 9,000 years ago—long before pottery was invented. Woven from a variety of plant materials by three basic techniques—plaiting, twining, and coiling—baskets had many uses. Flat trays were used for serving food and for winnowing seeds and parching them with hot coals. Deep baskets covered with resin were made to carry water. Some were woven very tightly for cooking with hot stones. Others were used for storage or carrying burdens.

BASKET MATERIALS came from many sources. Branches of shrubs, such as willow, hazel, and redbud, were used in coils, or split to make strands for sewing and twining. Bundles of grass and rush stems were used in coiling. Material for fine baskets was obtained from inner cedar bark, spruce and fern root, and the fibers of Indian hemp. In the Northeast, logs of oak, ash, and hickory were pounded until the wood separated into layers which were then split for plaited baskets. Cane was the most common material used in the Southeast.

Iroquois
corn-washing basket

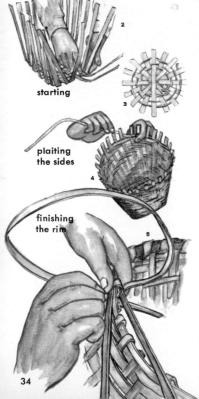

starting

plaiting
the sides

finishing
the rim

PLAITED BASKETS (1) are made by the most simple technique. Two sets of elements cross each other, alternately passing over and under those of the other set, to produce a checkerboard effect. Variations are made by changing the number of elements crossed at a time and by using different materials.

PLAITING A BASKET begins with weaving a mat for the bottom. The elements cross at right angles for a rectangular basket (2), but a cylindrical basket is started by crossing splints like spokes of a wheel (3) and winding the wefts in and out of them. Sides are started by bending splints upward.

As the sides are woven, a horizontal element, the weft, is passed in and out of the uprights, or warps (4). Colored strands may be introduced or weaving patterns may be created. In some baskets the splints are pushed tightly together; in others, spaces are left between them. If the basket is to have a flaring shape additional warps may be added.

The rim is the weakest part of a basket. To strengthen it the Iroquois used two splints to form a double hoop (5); the upper ends of the warps were held between them. The Cherokee bent them over a hoop; the Creek and Chitimacha twisted the ends of the warps into a false braid (p. 42); the Hopi tied the yucca splints of ring baskets (p. 52) over a sumac withe.

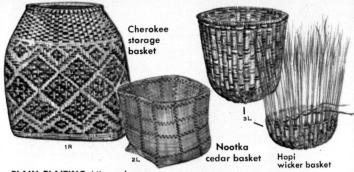

Cherokee storage basket

1 R

2 L

3 L

Nootka cedar basket

Hopi wicker basket

PLAIN PLAITING (4) produces a simple, regular checkerboard appearance. The technique is commonly used for mats. Decoration is usually with colored splints. Some baskets of wood splints are stiff, but flexible baskets are made with cedar bark (2), palm fronds, and strips of yucca leaves.

TWILL PLAITING (5) creates textured surfaces and geometric patterns. This is done by varying the number and sequence of the interwoven elements. In herringbone patterns, two splints are crossed each time and the crossing splint moves up one place. Some twill plaiting produces diagonal patterns (1).

WICKER PLAITING (6) is a plaiting technique, but its results are distinct because the warp elements are rigid and rodlike. The cross elements may be stiff or quite flexible but the articles produced are stiff and hard. Many utility baskets were made this way. Today's finest and most colorful wicker baskets are made by the Hopi (3).

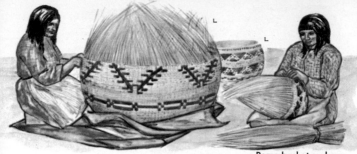

TWINED BASKETS consist of a set of vertical warps with two or more horizontal wefts which twine around each other as they weave in and out between the warps (2-p. 37). This technique produced some of the finest baskets the Indians made. Because the twined wefts held the warps firmly in position, it was also the best technique for making utility pack baskets, seed beaters, fish traps, and other stiff openwork articles (p. 49). Fine, flexible warp elements were used by the Indians of northern California and adjacent areas to make thin-walled attractive baskets (p. 47).

Twining soft baskets—Tlingit

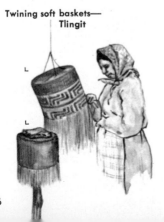

SOFT TWINED BASKETS are made by using warp elements so fine that they provide no rigidity to the basket. The common materials are grasses and fine strands of bark or root fibers. To weave these flexible warps they were suspended, and the baskets were woven upside down. This was the common method on the Northwest Coast (p. 44). Soft baskets were used as pouches or bags in Oregon and Washington (p. 46) and also in the Great Lakes region (p. 61).

PLAIN TWINE (1, 2) usually shows vertical ridges formed as each pair of wefts twines around the warp elements and stacks above each other in regular succession. Each twist of the wefts encloses the same warp or group of warps.

TWILL TWINE (3, 4) may show subtle diagonal ridging on the outside and an interlocking weft pattern like bricks in a wall. Each weft twist encloses two or more warps; these are different warps from those enclosed in the twist below.

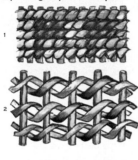

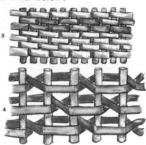

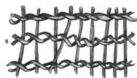

OPEN TWINE (5) is done with both plain and twill techniques. Separated warps are held in place by twined wefts, also separated from each other. This produces an openwork effect. It is most often used for heavy-duty utility baskets (p. 54).

WRAP TWINE (6), typical of the west coast, uses two stiff elements and one flexible weft. The stiff elements cross and are held together by the weft. The inside (6) resembles coiling; the outside (7) shows a pattern of diagonal twists.

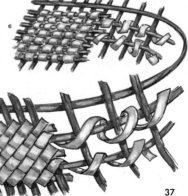

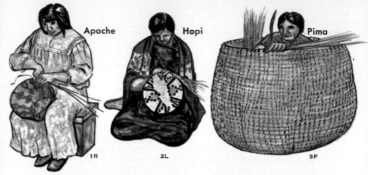

Apache 1R Hopi 2L Pima 3F

COILED BASKETS are made like coiled pottery. Thin strips of fibers, wood, leaves or grass are wrapped into a bundle which is coiled around in a continuous spiral (1). As new material is added to the coil, the lashing stitches bind it together and sew it to the previous loop of the coil (2). Coiled baskets can be identified by the corrugations which form a spiral on the bottom and become horizontal on the sides (3).

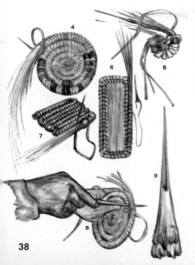

BEGINNING A BASKET varies. The Hopi, Apache, Pima, Pomo twist a spiral with a thin bundle (4); the Papago tie four strands into a knot and bend the ends around (5); the Salish sew the first coils around a piece of wood (6) or make a meander or zigzag (7).

SEWING is done with a sharp awl of bone (9) or metal. A hole is punched in the previous coil and a thin fiber strand is pushed through and bound over the material in the new coil (8). The sewing is a continuous spiral, binding the two coils together. In the Southwest coils turn counterclockwise but clockwise in deep, decorated baskets.

ONE-ROD COILING (1) was done by the Pomo and Paiute. The rods are thin branches of willow or redbud and the stitches fit between each other to make stiff baskets with smooth sides. Crude dice baskets were made in the Plains.

THREE-ROD COILING (2), common from the Southwest to California, was typical of the western Apache, Yavapai, Havasupai, Chemehuevi, Paiute, Washo, Miwok, Maidu, and Pomo. One rod, which was smaller, was moved to change the curve of the sides.

THREE-ROD STACKED COILING (3) was done only by the Mescalero Apache. The thin rods were sewn loosely with interlocked yucca leaf stitching.

FIVE-ROD COILING (4) is done by the Jicarilla Apache. The coils are thick and are sewn with shiny, gold sumac stitches.

FIBER BUNDLE COILING (5) is typical of four major areas. In the Southwest the Hopi make thick, soft coils of grass and the Pima and Papago make thin ones. In southern California the baskets of the Yokuts and Mono have thin grass coils; Mission coils are thick and soft. The Klikitat, Yakima, and Salish of the Cascades make baskets with thick, hard coils of cedar root strips. In the Lakes area the Chippewa make fiber bundle baskets (6) of sweet grass. Some tribes (Navajo and Apache) combined rods with a bundle.

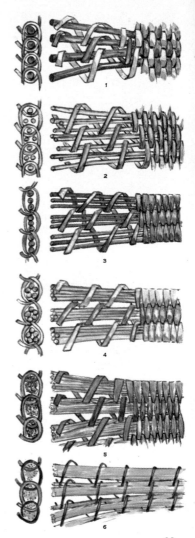

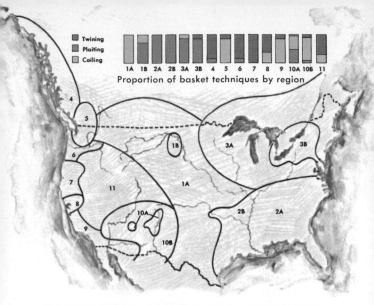

Proportion of basket techniques by region

Twining
Plaiting
Coiling

1A 1B 2A 2B 3A 3B 4 5 6 7 8 9 10A 10B 11

MAJOR BASKET REGIONS AND TECHNIQUES are shown above. Coiling and twining were primarily western techniques; plaiting eastern. Almost all tribes used simple plaiting or twining to make utilitarian objects: fish traps, carrying baskets, and sieves. It is in the techniques and materials used for decoration that real distinctions become apparent. Environment was also a factor; baskets reflected availability of materials.

1. PLAINS-UPPER MISSOURI. (A) **Plains:** Crude coiling; rare. (B) **Upper Missouri:** Plaited splint baskets with rod corners.

2. SOUTHEAST. (A) Cane and oak splint plaiting and root-runner wicker work. (B) **Oklahoma Cherokee:** Cane plaiting and wicker.

3. NORTHEAST. (A) **Algonkian:** Splint plaiting and sweet grass coiling. (B) **Iroquois:** Splint plaiting and cornhusk twining.

4. NORTHWEST COAST. Fine split root twining decorated with grass, false embroidery or painting; open twining and some plaiting.

5. CASCADES. Stiff coiling of bundles of roots or splints decorated with imbrication and beading. Storage and cooking baskets; rare use of twining.

6. COAST-COLUMBIA. Fine twining decorated with half-twist overlay technique; most important occurrence of wraptwine construction; some plaiting and many soft basket-bags decorated with designs in wraptwine and false embroidery.

7. NORTHERN CALIFORNIA. Fine, flexible twining decorated or covered with overlay of bear grass and fern stems: half-twist overlay was used in the west, full-twist overlay in the eastern section.

8. CENTRAL CALIFORNIA. Various twining techniques among the Pomo, also utility openwork twining and fine single-rod and three-rod coiling.

9. SOUTHERN CALIFORNIA-DESERT. Fine coiling with bundles of grass and plant fibers sewn with grass, rush or wood splints. Utility twining; rare use of plaiting.

10. SOUTHWEST. (A) **Pueblo:** Thick grass bundle coiling, wicker and yucca plaiting. (B) **Circum-Pueblo:** Three to five-rod coiling, some twining for burden baskets and bottles.

11. BASIN. Twined utility baskets, etc. Some coiling.

THE PLAINS-UPPER MISSOURI tribes all hunted buffalo, but those on the upper Missouri also farmed.

PLAINS tribes made only small crudely coiled bowl-shaped baskets for throwing dice (1). They were of one- or two-rod construction (Sioux, Cheyenne, Arapaho, Kiowa, Comanche, and other buffalo hunters).

UPPER MISSOURI tribes made plaited pack baskets with U-shaped rods reinforcing the sides and rims (2). The plaiting technique and the tribes came from the Southeast (Arikara, Hidatsa, Mandan).

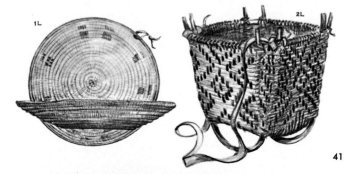

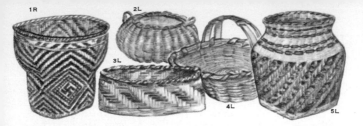

THE CHEROKEE AND CATAWBA more commonly make baskets of oak splints than of cane. Geometric patterns are produced in plain and twill plaiting with dyed splints (1, 3, 5).

Rims are finished with a hoop and bound with hickory bark (4). Many are made on the Qualla Reservation in North Carolina; wicker baskets of root runner (2) in Oklahoma.

THE SOUTHEAST REGION makes plaited baskets of wild cane or oak splints. The finest baskets are made with "double weave" technique which produces different designs on the two surfaces (12).

THE CHOCTAW, CHICKASAW, CREEK made fine cane baskets in Louisiana, Mississippi, and Oklahoma. Unique "elbow baskets" (6) and "cow nose" (10) shapes are decorated with natural and aniline dyes. Winnowing (7) and wall (9) baskets were common.

THE CHITIMACHA, ATAKAPA, in Louisiana, made colorful baskets of narrow cane splints. Black, red, yellow, and orange are combined in patterns of meanders (12) and zigzags. Baskets (13) and pouches with slip-on tops (8) were common; rims have a double spiral twist (11).

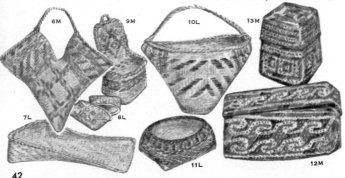

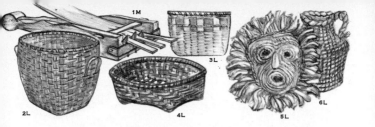

THE IROQUOIS are related to the Cherokee by language, and their basket techniques are similar. Utility forms of ash splints are most common: corn washers (p. 34), pack baskets (2), berry pickers (3), and sieves (4) for washing hominy. They also braid cornhusks and sew them together for mats or medicine masks (5) or twine them to make salt and tobacco bottles (6).

THE NORTHEAST REGION makes plaited baskets of hardwood splints with double rim hoops. To make splints, logs are soaked and pounded until the annual layers peel off. They are slit with a basket gauge (1).

THE ALGONKIAN TRIBES in the east use plain plaiting with decorative patterns of dyed splints (7-Micmac), simple painted designs (8-Nauset) and stamping with a piece of potato (9-Mohegan). Curlicue work, a twisted overlay strip (10-Passamaquoddy), is unique here. Soft diagonally plaited bags of cedar bark are used for storing wild rice. Sweet grass is widely used in coils (11-Ojibwa) or combined with splint plaiting (7). Market baskets with hoop handles (12), here and in the Southeast, are made of willow or basswood withes and also with splints.

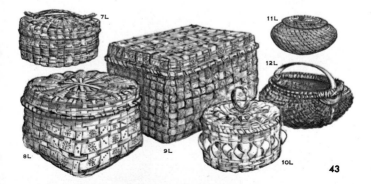

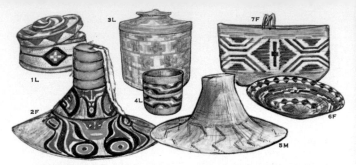

THE NORTHWEST COAST region, from southern Alaska to Puget Sound, produced thin, flexible baskets made of finely split spruce roots and a variety of utility baskets from cedar splints and other materials. The finest baskets were twined but some plaiting was done.

DECORATION on fine twined hats consists of raised lines of twill weave (5-Haida) or painted animal designs (2-Kwakiutl). The basket rings on top indicate the number of feasts given. The Tlingit used false embroidery (10) to decorate women's work baskets (1) and trinket baskets with rattle-topped lids: also berry baskets (4) and flat trays (6) which were folded into carrying bags (7). They also did open cross-warp weaving (8) and made open-work twined baskets for gathering clams (9-Kwakiutl).

FALSE EMBROIDERY (10) is done with a strand of colored grass which is coiled around each weft stitch as it is twisted toward the outside of the basket. This strand is added during the construction of the basket and shows only on one surface. The loops of colored grass look like twining when finished but they slant in the opposite direction from the twined stitches. Decoration was also achieved by varying the weave; sections of twill twining or "skip stitch" (5) produced relief patterns.

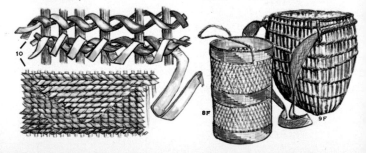

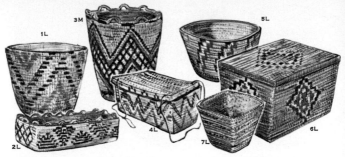

THE CASCADES REGION extends along the Cascade Range in British Columbia and Washington. Stiff coiled baskets are made here with cedar or spruce root bundles. In storage baskets the coils are often wide and flat; in cooking forms the coils are thin and round.

IMBRICATION (9) is unique to this area. A surface of rectangular blocks is produced by covering the coils with a strip of colored grass or cherry bark which is fastened by folding it under each stitch when the coils are sewn. All imbricated baskets are sometimes called "Klikitat," but only the tall narrow ones with looped rims (3) are unique to this tribe. They, and the neighboring Chilcotin, also made flaring oval pack baskets with overall designs (1). Some were used for cooking.

On the Fraser and Thompson rivers further north the common basket form is rectangular. Some are completely covered with imbrication (2, 4), but on others only the designs are imbricated (5, 6). Some with fitted lids are used for storage (4, 6).

BEADING (8) is another distinctive decorative technique in this area. A colored strip of grass or bark is laid along the coil and fastened with spaced stitches. Beading may be combined with imbrication (7).

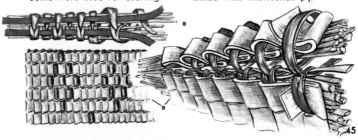

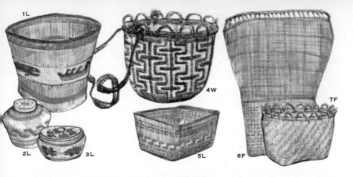

THE COAST-COLUMBIA REGION, extending from the Olympic Peninsula to California and up the Columbia River, is noted for fine twined baskets with overlay decoration. Wrap twine technique is used to decorate soft fiber bags as well as to make baskets.

OREGON-WASHINGTON is an area of small tribes and many kinds of baskets. Wrap twine (p. 37) with overlay is the most distinctive. The Makah of the Olympic Peninsula make bowls (1) and boxes (2, 3) covered with white squaw grass and colored figures. Using plain twine technique (p. 37), the Chehalis and Quinault (5) made stiff twined baskets (4) decorated with half-twist overlay (9-p. 47).

Splint and rush plaiting was common among the Nootka (6) and Salish (7). Twined Skokomish soft rush bags (8) were covered with half-twist overlay. On the Columbia River the cylindrical "sally-bags" of the Wasco and Wishram (9, 10) have strange life-figures done with wrap twine. The Nez Percé made soft rush bags (11, 12) covered with cornhusk false embroidery (p. 44) and colored wool designs.

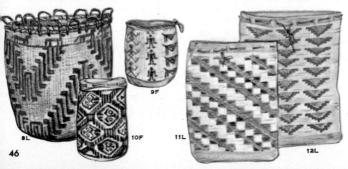

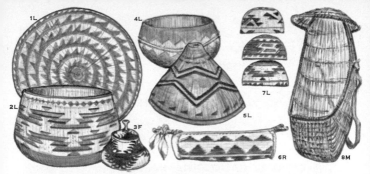

NORTHERN CALIFORNIA was the center for fine over-lay twined baskets in which the wefts of conifer roots are covered with strands of glossy yellow bear grass or shiny black fern stem. The overlay strands may cover the entire surface or only the decorative patterns.

HALF-TWIST OVERLAY (9) was used by the Yurok, Karok, and Hupa of northwestern California for fine flexible mats (1), storage baskets (2), trinket baskets (3), bowls for cooking (4), women's hats (7), and dance baskets (6). Utility baskets and Hupa cradles (8) were made in open-work twine with stiff warps.

FULL-TWIST OVERLAY (10) is found in northeastern California. The designs show on both sur-faces; half-twist shows only on the exterior. The Modoc and Klamath made tule baskets and hats (5). The northern Maidu, Shasta and Achomawi had stor-age forms (11), women's hats (12) and food baskets (13).

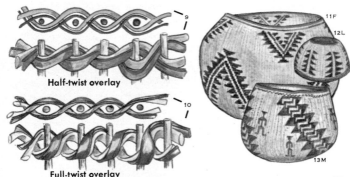

Half-twist overlay

Full-twist overlay

47

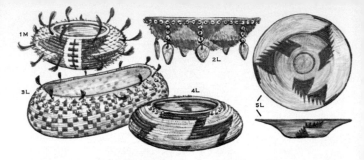

THE CENTRAL CALIFORNIA REGION produced both twined and coiled baskets. Particularly among the Pomo, the diversity of forms, the excellence of techniques, and the variety of decoration surpassed any other region. Basketry was the supreme art of these people.

POMO COILED BASKETS are only one variety this tribe made. The most spectacular are the ceremonial baskets spotted with feathers of quail and woodpecker (1) or decorated with feather mosaic (2). Beads were used to decorate gift baskets (3). The basic shape is globular (4); the clockwise coils are one-rod or three-rod stitched with sedge root (5).

POMO TWINED BASKETS are basic utility pieces but are beautifully made and decorated. Plain and twill twine, and three-strand and braided twine were combined with wrap twine in large storage forms, in gathering baskets of distinct shape (6) and in bowls for cooking acorn mush (9). A lattice or T-twine (10) technique was used for stiff mortar hoppers (7) and bowls (8).

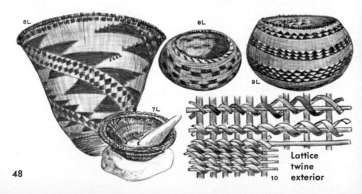

Lattice twine exterior

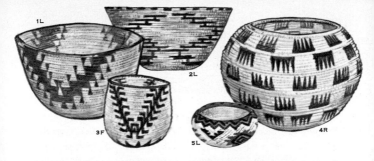

MAIDU, MIWOK, AND WINTUN

made baskets that reflected the influence of their neighbors. Like the Pomo, they made some twined baskets but their best baskets are coiled. The southern Miwok made some coiled baskets with grass bundles, like the Yokuts, but the typical coil here is single-rod or three-rod bundle construction (p. 39). Rod coiling extended into the Basin and Southwest regions.

The distinctive basket forms in this area are bowls with flaring sides. Among the Maidu they are decorated with triangles in red-brown cherry bark (1). Miwok bowls are similar but the designs are more delicate

and almost always black (2). Globular forms are also common (3), the typical shape among the Washo. One-rod and three-rod coiling were used. The Washo made some of the finest specimens (4). Like the Pomo, they also covered baskets with a network of glass beads (5).

The Maidu and Wintun made fine twined pack baskets (6) and bowls (7) with full-twist overlay but twining was used chiefly for stiff openwork utility articles such as seed beaters (8), fish and bird traps (9) and bowls (10). Similar utility baskets are found throughout this area and in all adjacent basket regions.

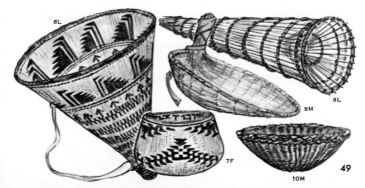

49

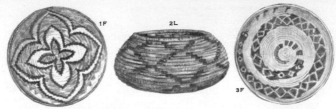

THE SOUTHERN CALIFORNIA-DESERT REGION is
known for excellent coiled baskets made with bundles
of grass or rush stems, shredded yucca leaves, and
other fibers. The California baskets are coiled toward
the right, Arizona baskets toward the left. A variety
of sewing materials was used and designs differ.

THE MISSION TRIBES once made excellent and colorful coiled baskets. The coils were loose and rather large (1/4 inch), and were sewn with stitches of juncus rush, which gave them a distinctive glossy surface of mottled yellow brown. The most typical form was a shallow bowl (1) but globular bowls (2) and oval trays were made. Some designs were asymmetric geometric motifs, others were life forms such as snakes (3), birds, and other animals. Black and deep red were favorite colors.

YOKUTS, MONO, PANAMINT and some neighbor tribes made baskets with thin (1/8 inch) coils wound clockwise. Yokuts coils were grass stems sewn with gray-tan marsh grass (4, 5, 6). The Mono (7) and Panamint (9) used grass stems and also made one and three-rod coils which were sewn with yellow willow. Distinctive forms are the "bottle-necks" (4) decorated with red yarn or feathers, trays (5) globular jars (7, 8) and flaring bowls (6, 9). Bands of diamonds form a typical "rattlesnake" design (6, 8, 9).

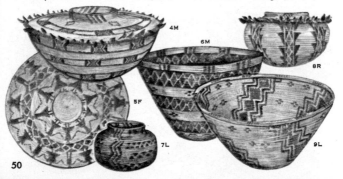

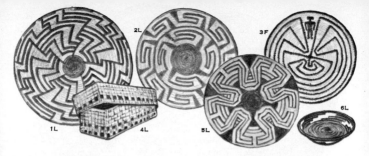

PIMA BASKETS are stitched with willow. Tough devil's claw fiber is used for designs, the bottom, and the rim; usually finished with herringbone stitch. The narrow coils of split cattail stems produce thin, smooth walls that are light and springy. Pima designs are light, with whorls or zigzags (1) and frets (2). Maze patterns are used (3) and repeated elements (5) representing coyote tracks or other designs. Miniature pieces, less than an inch across, are made for sale and some women have specialized in small horsehair baskets (6). Huge granaries were once coiled of bundles of wheat straw (p. 38), and some plaiting is done with agave leaf (4).

PAPAGO BASKETS were formerly sewn with willow. Bear grass and yucca were used in the coils, and the basket walls were pounded to make them smooth. Papago baskets (7) are generally darker than Pima; also stiffer and heavier. A four-strand starting knot is common (5-p. 38). The Papago made waterproof bowls for brewing "tiswin" wine (8). Modern baskets are made of bear grass (9, 10) or yucca (14). Effigies of animals and people (11) are sold, and life figures are used in decoration (10, 14). A decorative technique of split-stitching has been developed (12, 13). The Papago probably make more baskets today than any other tribe.

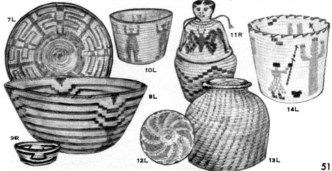

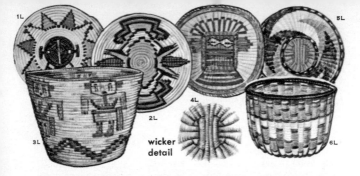

wicker detail

THE SOUTHWEST REGION in Arizona and New Mexico is the most important center for contemporary Indian arts. Both the Pueblo and Circum-Pueblo peoples have made fine baskets since early times and many are made today for home use and for sale to visitors.

PUEBLO baskets were diverse and common in early days; today the craft is important only among the Hopi. Coiled baskets are made on Second Mesa. The coils, thick and rather soft, are made of bundles of grass or yucca sewn with yucca leaf strands dyed in bright colors. Flat trays (1, 2) and deep baskets (3) are decorated with geometric designs, plants, and kachinas.

Wicker baskets from the Hopi village of Oraibi on Third Mesa are the finest in America, with brilliant colored kachinas (4), abstract birds, whirlwinds (5), and checks (6). Sumac twigs, used for the baskets, make them stiff and hard. Wicker is also used in cradles (7) and crude "peach baskets" (8) with U-shaped corner rods. At Zuni and San Juan (9), openwork bowls are made with simple designs.

Plaiting with yucca leaf for mats and "ring baskets" (10) is an ancient art still found at Hopi and Jemez. Some trays have wicker edges (11).

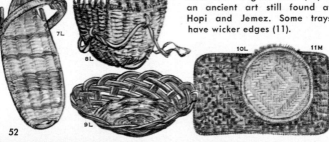

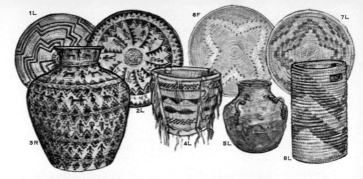

CIRCUM-PUEBLO tribes in the Southwest area surrounding the Pueblo villages make excellent coiled baskets with rod-bundle construction (p. 39). The coils in bowl shapes are usually counterclockwise. Twined baskets are made in bottle shapes and as pack baskets.

WESTERN APACHE coiled baskets are made with willow stitching around coils of three small rods (p. 39). This produces a hard, stiff basket with marked corrugations. Designs are usually whirling linear patterns (1) and figures of men and dogs (2, 3). Bowl shapes and large storage jars (3) are common. Twined pack baskets (4), used for gifts, have buckskin fringe and painted designs, and usually corner reinforcing rods. Bottles (5) are waterproofed with piñon gum.

MESCALERO APACHE coiling (6) is flat and loose with three rods stacked above each other (p. 39). Yucca leaf stitching produces simple geometric designs.

JICARILLA APACHE baskets (7, 8) have thick five-rod coils (p. 39) sewn with shiny gold sumac. Bright aniline dyes fade quickly to a soft pastel.

HAVASUPAI coiled baskets have black linear designs on three-rod construction. Some have light-colored rims (10) and the designs tend to be bold (11). Fine twining was done in bottle forms for seeds or water (9) and for pack baskets with hoop rims and leather points (12).

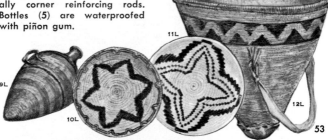

53

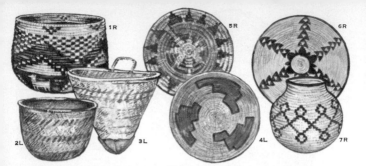

YAVAPAI three-rod coiled baskets are similar to those of Apache in technique and design; deep bowls are distinct (1).

WALAPAI twined baskets are made with stiff sumac twigs. Typical shape is a deep bowl with flat rim made for sale (2). Carrying baskets are used (3).

NAVAJO baskets are rare, have simple designs (4) and coils made of two rods and a fiber bundle. The "wedding baskets" (5) are usually made by the Paiute; have three-rod coils.

CHEMEHUEVI three-rod coiling turns clockwise (6) and stitching is willow and devil claw (7).

THE BASIN REGION extends from Arizona to Oregon and includes all of Utah and Nevada. For the people in this area the most important implements were baskets.

PAIUTE, UTE, BANNOCK, AND SHOSHONI made plain twine utilitarian baskets. Large conical pack baskets (8) were made in close and open twine.

Babies were carried in open-twine hooded cradles (9). Bottles for seeds and water were twined and also coiled (10). Women used fan-shaped seed beaters (11) woven in open twine to knock seeds from bushes into twill-twine trays (12); found throughout the west.

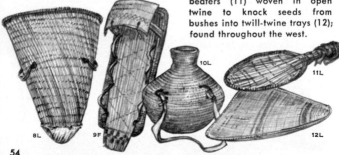

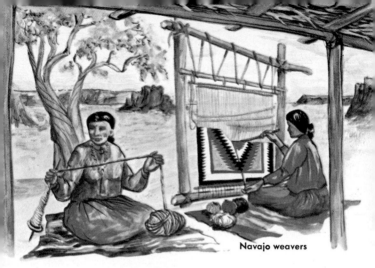

Navajo weavers

TEXTILES

Textiles may be coarse or fine and woven of many different kinds of fibers. Many Indian tribes of North America produced textiles by techniques of finger weaving (pp. 57-64): twining and plaiting (as in baskets), netting, looping, knitting, and crocheting. Loom weaving (pp. 64-75) was done only in the Southwest.

Nine thousand years ago Indians of the Archaic cultures wove rush mats and fiber sandals. In the Southwest, textiles occurred in the Cochise Culture (1000 B.C.) and in the Mogollon Culture (300 B.C.-1350 A.D.). These beginnings, with the crafts of the Basketmakers (300-500 A.D.), led to weaving by modern Southwest Indians. Early Indians of the east and midwest wove textiles, too, perhaps as early as 1500 B.C. Cloth occurred in the Ohio Valley Adena-Hopewell cultures (800 B.C.-600 A.D.) and in sites of the Middle Mississippi Culture, continuing to early historic times.

SPINNING by Indians in the New World was done by hand or on a spindle, not on a spinning wheel. The range of fibers was reflected in the varied textures.

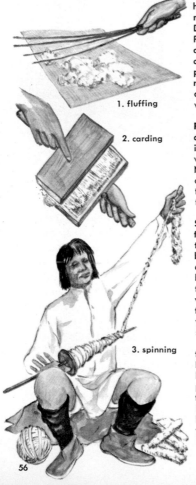

1. fluffing

2. carding

3. spinning

MATERIALS for textiles included hair of wild animals—buffalo, mountain goat, and moose. Dogs were raised for hair along Puget Sound; sheep were introduced by the Spaniards. Indians also used fibers of many wild plants: Indian hemp, nettle, milkweed, and the inner bark of cedar and basswood. Cotton was raised in the Southwest.

PREPARATION for spinning requires cleaning and straightening the fibers. Cotton used to be whipped lightly (1) to fluff it. Now weavers use European cards with wire teeth (2). Cotton or wool is combed between the cards to straighten fibers.

SPINDLES are used to pull the fibers into a thin hank and twist them into yarn. Some fibers, usually the coarse ones, are rolled on the spinner's leg, but cotton, wool, and hair are twisted on a spindle. This is a wooden rod that is rolled or twirled to twist and wind the yarn. A disc of wood, pottery, or stone acts as a flywheel.

Navajo twist the spindle between thumb and fingers; the Pueblo men roll it along the leg (3). A continuous strand is pulled from the loose bundle of fiber and twisted on the spindle. Black and white wool may be blended to make gray, or white yarn dyed. Yarn may be respun to make it hard and smooth.

FINGER WEAVING (pp. 57-64) without a loom is very old and widespread. Generally only the fingers are used but needles or weaving frames may be used.

KNITTING AND CROCHETING are still used in the Southwest for making footless socks (2) and lacy stockings (1) for dance costumes. In both techniques, a single thread is looped over and over through earlier loops with a hook (crocheting) or with needles (knitting).

LOOPING AND NETTING (3) are done by fastening the end of a strand to a needle or wrapping it around a bobbin (4) and passing it back over itself to make a series of loops. The loops were also twisted or knotted to produce nets. In California loose, elastic bags and hairnets were made. In Canada, rawhide strips were looped to make bags. Carrying nets (5) were made by the Pima.

PLAITING AND TWINING, also found in baskets (pp. 34-37), use multiple strands which cross each other. The weaver uses his fingers, sometimes aided by matting needles, bobbins, or weaving frames. In weaving mats or blankets, the warp may be hung from a horizontal rod (6). Strips of rabbit fur were plaited into winter robes (6) in the Southwest, California, Lakes, Basin and Sub-Arctic areas.

Textiles and baskets are often difficult to tell apart. Both use similar techniques and materials. A clear distinction is often impossible.

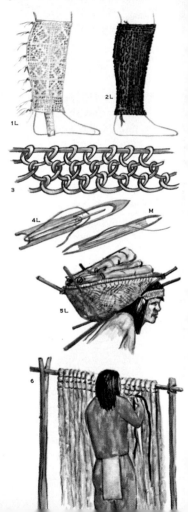

1L

2L

3

4L

M

5L

6

1L

2F

TWINED AND PLAITED TEXTILES were finger woven on the Northwest Coast: chiefly twining in the north and plaiting in the south. The coast from southern Alaska to Puget Sound has a relatively mild climate and the Indians here generally went naked or wore only loose garments of matting or of woven goat hair and cedar bark. In spite of the lack of a true loom, they produced textiles that rivaled the finest weaving of the Southwest.

CHILKAT BLANKETS (1, 2) are named for the band of Tlingit Indians of southern Alaska who wove them. The warps are shredded cedar bark twisted with mountain goat's wool; the wefts are pure wool. Three goat skins were required for the wool in one blanket. Some wool was picked from bushes where it

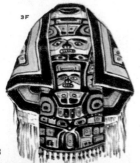

3F

had caught when the mountain goats were shedding their winter coats.

Chilkat blankets, ceremonial shirts (3), and kilts were not woven on a true loom. The warps were hung from a horizontal bar and the double weft strands were twined across them (p. 57). These textiles, which are very rare, were worn only by chiefs. Brilliant blue-green dye was made by soaking copper in urine. Other colors came from barks and roots.

The weavers along the Northwest Coast were women, who copied patterns which the men painted on boards. These designs are usually stylized animals: bears, eagles, and sea monsters.

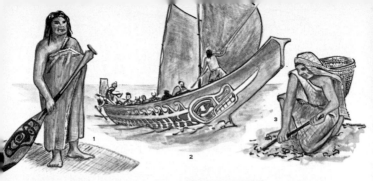

CEDAR MATS

CEDAR MATS were very important to the Indians. On the Northwest Coast mats served as clothing for both men (1) and women (3), as sleeping pads and blankets, as sails for the long boats (2), and as wrapping for tools and ceremonial equipment.

Cedar bark was soaked and then shredded by hanging it over the edge of a canoe paddle blade and beating it with a bone tool (p. 127). The fiber was rolled into a coarse yarn and woven like a Chilkat blanket with separated wefts of nettle or trade string; edges were trimmed with mountain goat wool or sea otter fur. Robes were soft, warm, and rainproof. Cattail mats were sewn in the Puget Sound area.

SALISH BLANKETS

SALISH BLANKETS are unique in material and method of finger weaving. The northern Salish twined like the Chilkat, but the rest of the tribe made thick, twill-plaited white blankets (4) of mountain goat wool mixed with down, cattail fluff, and the hair of white dogs. A later blanket type (5), using colored commercial yarns for wefts, was finer and more decorative.

The Salish weaving frame consisted of two wooden bars wedged into slots between posts (6). The warp cords were wound around them and were also looped around a cord. This was pulled out when the blanket was finished, removing the textile from the frame.

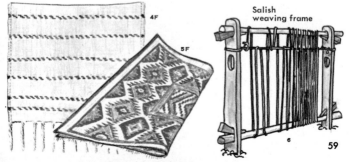

Salish weaving frame

59

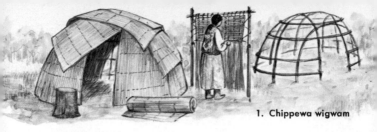

1. Chippewa wigwam

FINGER-WOVEN MATS, BAGS, AND SASHES were woven without looms by the Indian tribes of the Prairie, Lakes and Northeast areas. Both vegetal and animal fibers were used to make sashes and bags but rarely used for robes and other clothing. Mats were made from rushes, cornhusks, and bark. Twining and simple plaiting were the most important techniques, but diagonal plaiting (sometimes called braiding) was also used. In the lower St. Lawrence Valley, socks and mittens were knitted from moose-hair yarn.

MATS of cattail stems (2) were used by the Chippewa, Ottowa, Menomini, and other Algonkian tribes of the Lakes area. The stems were sewn together on a cord to make insulated sides for the winter wigwam (1). Another type of mat, made of plaited splints of cedar bark (3), was used for partitions, floor coverings, and inner walls.

The finest mats (4) were made of rushes and basswood fiber. These were woven on a frame (1). The rush warps were hung loose from a bar, and wefts of twisted basswood fibers were plaited or twined across them.

2L 3L 4L

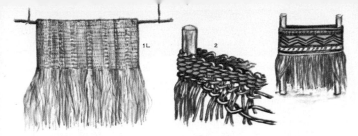

BAGS were woven by the Indians in the Lakes and Prairie areas. Untwisted basswood fibers were hung over a rod and weft cords twisted through them in a continuous spiral (1). To finish, the rod was removed and the warps braided around the rim. Bags were made also of twisted yarn twined on loose warps hung from a cord stretched around two springy stakes (2). When the bag was finished, it was slipped off the sticks and the open end sewed to make the bottom. The hanging warps were braided around the rim. Openwork bags of twisted basswood fibers (3) were used for washing corn in the Lakes area.

YARN BAGS were made in a variety of weaves. Diagonal twine was basic, but wrap twine (p. 37) was used in designs. The early bags (4) were made of moose or buffalo hair mixed with vegetal fibers. These fibers were obtained by soaking stalks of nettle, milkweed and Indian hemp (5, 6) or from basswood and linden bark.

After 1850, commercial wool yarn from traders was used to make bags (7, 8, 9). Some were large (18" x 20") and used for storage; small ones were used for charms. Early designs are often symbolic (4); later patterns are bands of geometric figures which differ on the two sides.

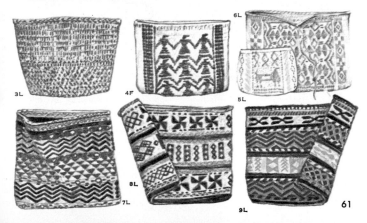

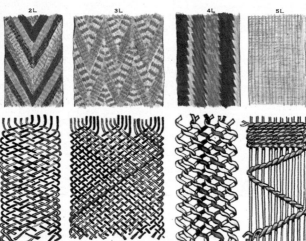

SASHES woven in bright geometric patterns were major items in the costumes of the eastern Indians from Georgia to Labrador. They were also important in the Lakes and Prairie areas (1-Pawnee) and were traded west through the Plains tribes to the Rockies.

The northeast Indians wove diagonal plaited wool sashes with angular designs. Before contact with white traders, the sashes were woven of vegetal fibers mixed with moose and buffalo hair. Wool sashes became popular when yarn and trade sashes were acquired.

DOUBLE BAND PLAITING (2) begins with a group of hanging strands; the center ones are plaited across to the edge. In turn, each strand is plaited across and back.

LOOPING OR NETTING (4) is used to unite the multiple bands making up some large sashes. This technique is often used for the weaving of the entire sash.

MULTIPLE BAND PLAITING (3) is done by dividing the strands into groups. Each strand is plaited across the entire sash and back again.

TWINING (5) was done in many areas, sometimes on stretched warps. The alignment of the weft twists gives the sash a distinctive ribbed surface.

ORNAMENTAL SASHES were worn around the waist with the long fringes trailing or hung over one or both shoulders in bandolier fashion. They were also wrapped around the head like a turban (1). Short pieces were tied around the arms or worn on the legs as garters. Sometimes they were used to tie or carry medicine bundles or to decorate a weapon.

Glass beads were often woven into the sashes (p. 62) or threaded on the long fringes at each end. Silver brooches were also used to decorate sashes; sashes to ornament dress.

IROQUOIS TUMPLINES are tightly woven of basswood, elm or nettle fiber (2) and usually decorated with dyed moose hair applied in the technique of false embroidery (p. 44). A pair of wefts are twined across twisted warp strands (5-p. 62). The long ties are flat braiding. Tumplines are mainly used to carry loads.

CALIFORNIA TEXTILES are almost all openwork fabrics made by looping, netting, or crocheting. The materials are rolled cords of wild hemp, milkweed, iris leaf fiber, and bark. Painted strips of iris fiber (3) were hung by the Hupa from their ceremonial dance headdresses. Shoulder bags (4) of looped openwork, decorated with shell pendants, were made by the Pomo. The Pomo also made excellent carrying nets (5) with white shell beads woven into the headbands for decoration.

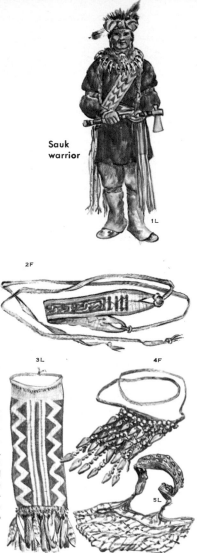

Sauk warrior

1L

2F

3L

4F

5L

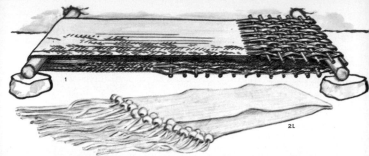

FRAME BRAIDING is a unique finger weaving technique now used by the Hopi. They make a white cotton ceremonial "rain sash" or "wedding sash" (2) which is traded to all the other Pueblo towns. The Hopi bride carries one in her reed bundle (p. 71) and her husband wears it in ceremonial dances. Wood and cornhusk rings decorate the long fringe.

To make a wedding sash, the weaver winds a cotton cord more than a hundred times in a spiral between two rods or rollers set rigidly in a frame or wall (1). There are no loose ends. Each taut strand in turn is pulled under three others and held in place with a retaining rod. Binding the strands into the fringe finishes off the ends of the sash (2).

THE TRUE LOOM is used by Indians only in the Southwest. In other areas textiles were finger woven, except for belts made with the European "reed" heddle (p. 90).

The Southwest is now and has long been the most important weaving area north of the Rio Grande. Weaving here is not only ancient but also still very important to the modern Indians. In spite of outside influences, it is done as it was a century ago.

The Hopi and the Navajo are today the best weavers. Other Pueblo groups now do very little weaving. The Apache were never weavers. Until 1900 the Pima wove cotton blankets on a horizontal frame. The Mohave and Yuma wove sashes and bags. Early textiles were woven of yucca, native cotton, other fibers, and human as well as animal hair. Wool was used after the Spaniards brought sheep to the area about 1600.

THE BELT LOOM is a true loom. It is the main type of native loom found south of the Rio Grande. Belt looms are much older than blanket looms, but are similar in character. They are used by Navajo women (1) and Hopi men. Among other Pueblos both men and women use them to weave long, narrow sashes for women's dresses (p. 70). They also weave smaller hair ties and garters for ceremonial costumes.

THE WARP in the belt loom, as in the vertical blanket loom (p. 66), is held taut during weaving and a heddle is used to raise groups of warp strands so the weft can be passed between them. The warp is wound in a spiral between two rods to form a flat tube like a roller towel (1, 4). One end is tied to a tree and the other to a belt that goes behind the weaver (1). As the weaver leans against the belt, the warp becomes taut. When there is no frame, the loom can be rolled up and put away with the bars and heddles in place.

SASHES (2, 3) made on a belt loom are traded widely in the Southwest. Commercial yarn is respun for the tight, colored warp that makes the surfaces; cotton string is used for the invisible weft. Designs—stripes or geometric figures—in black, red, white, or green are raised by "floating" certain threads in the warp over several rows of weft. Navajo and Pueblo sashes are very similar.

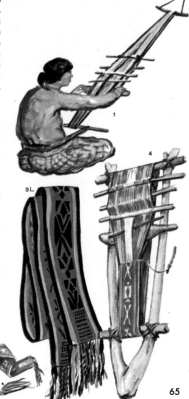

65

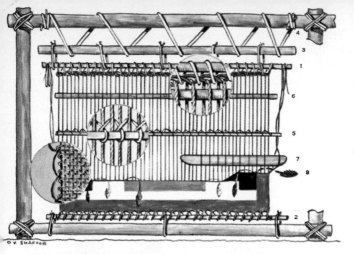

O. V. SHAFFER

THE VERTICAL LOOM

THE VERTICAL LOOM makes it possible to weave more rapidly than by finger weaving. The fabric is woven by passing weft threads over and under the strands that make up the warp (p. 67). This is done by moving whole groups of alternating warps by means of a heddle. As these warps are moved back and forth, the weft is passed between and bound in an over-and-under weave as in plaiting. The large vertical blanket loom may have been invented in the Southwest because it is not found in other parts of the Americas.

THE BLANKET LOOM consists basically of upper (1) and lower (2) horizontal warp bars. The warp is wound between in a figure-eight pattern. The warp is stretched by anchoring the warp bars within a frame.

The upper bar is tied first to a tension bar (3). This is suspended by a rope (4), which can be pulled to tighten the warp or loosened to lower the working edge of the blanket. A heddle rod (5) is attached to alternate warps by loose loops so it can be moved up and down. The heddle rod is used to pull these warps forward. A shed rod (6) is inserted in front of these warps and is used to push them back behind the others. A batten (7) separates the sets of warp for insertion of the weft (8).

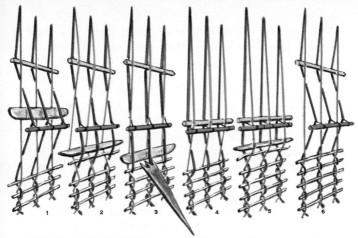

STEPS IN LOOM WEAVING are shown in these simplified diagrams above.

1. The heddle rod is pulled toward the weaver. The alternate sets of warp (red) attached to it move forward and separate from the others (blue). The batten is slipped into the space between them.

2. The batten is turned on its broad side to widen the space between the sets of warp. The weft is passed through the space.

3. The batten is turned on edge; a comb or the batten is used to push the weft down into place.

4. The batten is removed. The shed rod is pulled down; this pushes the set of red warp behind the blue warp and crosses them over the new weft strand.

5. The batten is inserted between the sets of warp and steps 2 and 3 are repeated.

6. The batten is removed, the shed rod pushed up, and the entire procedure is repeated.

WEAVING TOOLS are wood battens (7), pins (8), and combs (9). The smooth battens are used to open the shed and to pack the wefts. Pins and combs push the wefts into place between the warps. Sacking needles (10) are used to insert the final weft threads.

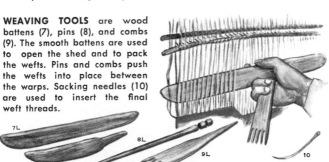

THE PUEBLO WEAVERS have long been the most sophisticated weavers in North America. Weaving first appeared in the Southwest with the Cochise Culture about 1000 B.C. but true loom weaving did not occur until some time about the first century A.D., probably with belt looms brought from Mexico. All earlier textiles were finger woven. Nobody knows when the vertical blanket loom appeared in the Southwest, but it was in use in the Great Pueblo Period (A.D. 1050-1300). The ancestors of the Pueblo used vegetal fibers and animal hair in weaving; cotton was probably brought from Mexico with the first belt looms. Cotton was raised by most of the Pueblos until the 1900's, but has now been replaced by commercial cotton batting. By 1600 the Pueblos had sheep and the techniques used in weaving cotton were transferred to wool.

MEN'S CLOTHING changed from the traditional style about 1900 as denim pants and commercial cotton shirts were adopted. Early clothing consisted of cotton breechcloths, kilts, and rabbit fur robes. After contact with the Spaniards, cotton pants with a slit up the sides were worn with wool or cotton shirts. The shirts were poncho style, a rectangular piece of fabric with a hole for the head (1). The sides were open or loosely laced together. Some had sleeves (2) made from separate rectangles and laced or tied together at the shoulders. Cotton shirts of similar style were worn in the Rio Grande villages. Traditional kilts and sashes are still worn at ceremonial dances.

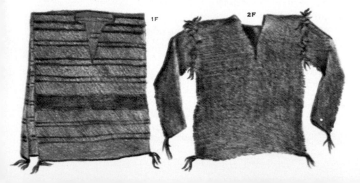

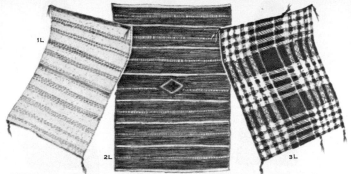

PUEBLO BLANKETS for clothing and bed covers are now woven only by the Hopi. In traditional fashion they are made by the men, as was true among all the Pueblos except Zuni. One blanket style is white or cream wool woven with blue, brown, or black stripes from side to side (1). The "Moki" blanket, with deep blue or black stripes (2), is one of the oldest styles. Shoulder blankets, worn by males, have checkered or tartan patterns of black, white, and gray (3) in diamond or diagonal twill. A few colored designs are woven for trade. Pueblo blankets are generally more loosely woven than Navajo textiles.

DECORATIONS on Pueblo fabrics are done by embroidery and a unique technique called embroidery weaving. The edges of cotton robes and kilts are embroidered with conventionalized cloud and rain symbols (3-p. 71). This is done with a needle after the fabric is woven and the design shows on only one side. Embroidery weaving (5), sometimes called "brocading," is applied in the weaving process and is done only by Hopi men to decorate dance sashes (4) and kilts. While the fabric is woven with a very thin weft, the design is applied by wrapping colored yarn around the warp (5).

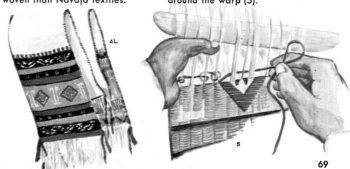

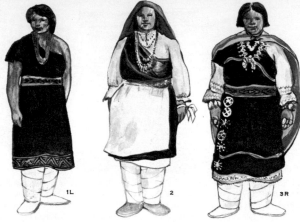

PUEBLO WOMEN'S DRESS changed more slowly than men's but their traditional style (1) has also disappeared except for fiesta costumes. This dress consists of a fine wool rectangle (manta) with a black or brown center woven in diagonal twill (p. 71). The long edges of Hopi dresses have wide bands of dark blue diamond twill (p. 71). Dresses are embroidered in blue at Zuni and in red at Acoma and other towns. The manta is folded under the left arm and pinned over the right shoulder.

A transitional style (2) added a gingham underdress with sleeves, an apron that was sometimes very fancy, and a cotton or silk shawl.

The modern fiesta dress (3), particularly at Zuni, is based upon the old-style manta worn in traditional fashion, but the sides are held together with ornate silver pins. A lace apron is sometimes worn and lace or colored petticoats hang below the skirt. Sateen blouses are worn with bright-patterned silk print shawls.

PLAIN WEAVE (4) or "basket" weave is simple plaiting in which alternate wefts cross the same warps. The warp and weft show equally in the fabric.

TAPESTRY WEAVE (5) is plain weave in which the warp threads are entirely covered by beating down the weft threads to compress them tightly together.

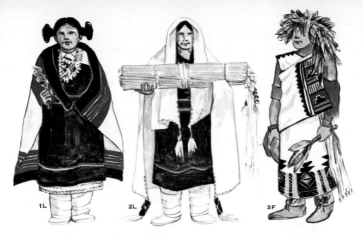

PUEBLO CEREMONIAL DRESS follows the traditional pattern very closely; "maidens' shawls" (1) are worn by unmarried girls, who also dress their hair in "butterfly" style and wear soft buckskin leggings. The shawls are woven of white cotton in a diagonal twill with broad edges of red and blue wool.

The Hopi "wedding robe" (2) is the largest cotton fabric woven by the Pueblos. It is a plain weave whitened with chalk. The groom's male relatives weave the robe, and the bride wears it as she carries the reed case with her wedding sash and other garments. The long tassels on the corners are symbols of fertility.

For major ceremonials the wedding robe is later embroidered with colorful commercial yarn (3). Shawls are decorated in the manner of kilts and sashes. This fine needlework is done by men in prescribed designs with medallions carrying motifs of birds, dragonflies, rain clouds, and butterflies. In traditional ceremonies the female roles were acted out by the men.

DIAGONAL TWILL WEAVE (4) is produced when each weft advances to the right passing over a different group of warp than the weft immediately below it.

DIAMOND TWILL (5) achieves a relief pattern by arranging the heddles to raise groups of warp so that each weft crosses a different set of warp.

NAVAJO WEAVING is done by the women. Copying techniques from the Pueblo Indians about 1700, the Navajo first wove dresses and blankets very similar to those of the Pueblos. When the Navajo were imprisoned at Fort Sumner from 1864 to 1868, their tradition was broken, and weavers were exposed to new ideas and materials. They acquired trade cloth and about 1890 began to weave rugs to sell instead of the traditional blankets. Until recently rugs were an important part of the Navajo economy.

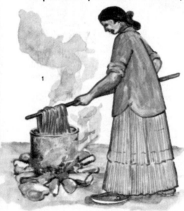

COLORS in Navajo fabrics have changed over the years. Early blankets had simple designs and somber colors like those of the Pueblo Indians. But the Navajo loved red and unraveled trade cloth to obtain red bayeta (baize) yarn. They used commercial yarn after 1865 and aniline dyes after 1870. Until 1915 they wove many garish rugs for tourists who regarded them as "typically" Indian. About 1920 a revival in weaving began as traders demanded high quality and encouraged use of subtle colors from vegetal dyes (1).

TRADITIONAL DRESSES (2) were made of two pieces of fine wool cloth fastened at both shoulders. Broad red borders are typical.

EARLY SHOULDER BLANKETS (3) for men are similar to Pueblo blankets with stripes running across the width (1875-90).

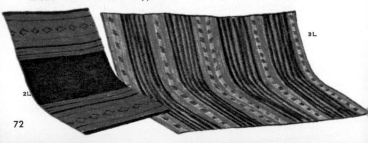

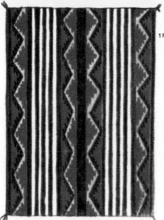

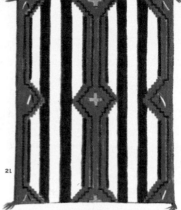

WOMEN'S SHOULDER BLANKETS (1) are smaller than men's but have the same striped pattern with three bands of repeated designs.

CLASSIC CHIEFS' BLANKETS (2), traded far beyond the Southwest, are rare. The design evolved from the simple striped style.

TERRACED DESIGNS (3) of overall diamonds or zigzags outlined with rectangular steps were common during the early period (1850-75).

GERMANTOWN YARNS (commercial) from Pennsylvania were used from 1880 to 1910. The aniline-dyed, four-ply yarns made "eye-dazzler" rugs (4).

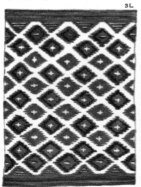

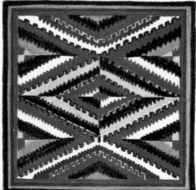

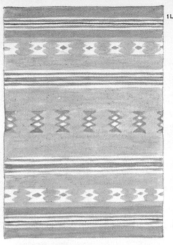

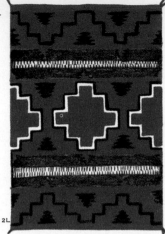

WIDE RUINS, west of Gallup, is a center for vegetal dye rugs in subtle colors. Designs are bands with geometric figures (1).

YEI FIGURES (3) are the divinities depicted in sand paintings. This type, made in the Shiprock area, has no sacred significance.

GANADO RUGS are marked by deep red backgrounds and bold, simple designs (2). This example is a revival of an early pattern.

TWO-FACE WEAVING (4) shows different designs on each surface. This results from laying two different wefts back to back.

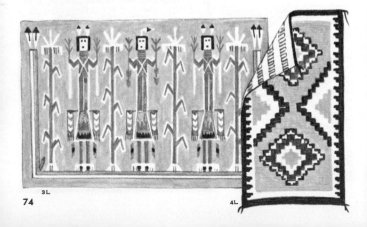

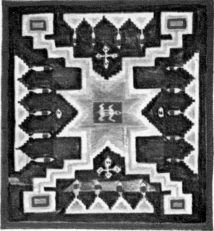

TWILL WEAVING is done by the Navajo in making saddle blankets (1). Although complex it is used in many areas.

STORM PATTERN RUGS have been made since 1900 near Tuba City. All have basic patterns of zigzags and rectangles (2).

KLAGETOH RUGS and Ganados are "typically" Navajo to most people. This color combination (3) is found in several areas.

TWO GRAY HILLS, an area between Shiprock and Gallup, makes rugs in natural colors and geometrical designs (4).

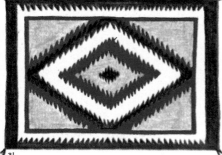

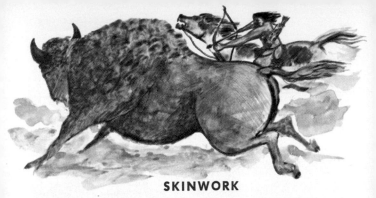

SKINWORK

All the Indians were hunters. Some hunted more than others, depending upon the game available in their area and the amount of food they raised in their fields. In the Plains and the north woods there was little gardening; hunting and gathering seeds and roots were the basic activities for providing food. Buffalo, deer, and elk were the most important animals for food and hides, but bear, caribou, and moose were also hunted. Small animals such as rabbits, squirrels, and possums were sought for food and for their soft furs.

SKINS were used to make clothing, tipi covers, shields, and boats, as well as to make a variety of containers to hold paints, guns, food, medicines, and even babies. Furs of large and small animals were used for robes and decoration. After the traders arrived furs became the most important way for the Indians to acquire the goods they wanted. Beaver pelts and buffalo hides were exchanged for knives, guns, iron pots, beads, cloth, and other goods which changed the old way of life.

PREPARATION OF SKINS requires a great deal of hard work. Skins cannot be used without being treated. They quickly become hard and stiff and begin to rot and smell. The Indians devised ways of treating skins; some processes simply kept them from spoiling, others produced soft buckskin (p. 80). In the Southwest and the Northeast the work was done by the men but in most other areas it was left to the women. Preparation of the large, heavy buffalo hides was done by the women.

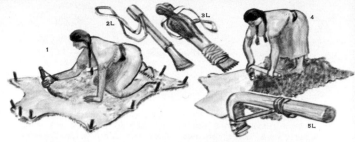

BUFFALO HIDES first had to be fleshed (1). With the skin staked out on the ground, chisel-like tools made from gun barrels (2) or buffalo leg bones (3) were used to chip off flesh and tissue. After the skin had dried in the sun it was scraped. A bent antler tool (5) with a flint or iron blade was used to plane the surface and thin the hide. If it was to be used as rawhide, the hair was then scraped off (4), or beaten off with a rock, and the skin was ready to use.

DEER HIDES were prepared by a longer process. Hair was removed (6) with beamers of bone (7) or wood with metal blades. The hide was tanned by rubbing it with an oily paste of brains and liver and soaking it in water for several days. It was then stretched, wrung out (8) and dried. It was softened in the Plains by pulling it around a thong (9); elsewhere it was stretched and beamed (10). Skins were smoked (11) to give color and keep them soft.

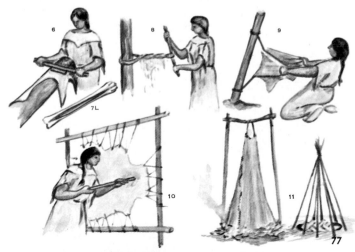

RAWHIDE SHIELDS could stop an arrow or a spear thrust. Some (1-Jemez) were made of two layers sewn together; most Plains shields (2-Crow) were made from the heavy skin of the bull buffalo's neck shrunk with heat to ¼-inch thick. Decorations were of spirits who provided protection (3-Hopi).

RAWHIDE is untanned skin: cream-colored, often translucent, hard but flexible, tough, lightweight, rainproof and almost unbreakable. When it is fresh and wet it can be bent and even molded; when it dries it is like hard, semiflexible plastic. Few people in the world used rawhide as well as the Indians of the Plains. For them it took the place of pottery, wood, and bark.

BINDINGS for tools were made with rawhide and sinew. The Plains tribes used wet rawhide to fasten stone heads on war clubs (4) and sewed it around the handles. As the skin dried, it shrank tight and hard. Stone mauls (5) were made similarly.

PARFLECHES (6, 7, 8) are large envelopes of rawhide used in the Plains to pack dried food and other things. They are folded from a single sheet (9) and painted with geometric designs. In camp they provided decoration for the inside of the tipi.

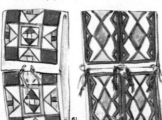

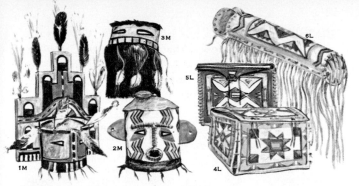

MASKS are used by the Pueblo Indians to represent the gods in their great ceremonial dances. Helmet masks like the Hopi Hemis (1) and Heheya (2) kachinas fitted over the head and were often topped with "tabletas" of wood. Other types were faces and half-masks (3) with horsehair fringe.

BOXES of rawhide (4-Sioux) were made in the Prairie and Lakes areas. Plains and Prairie boxes are made with sewn corners; some Lakes boxes were folded. The geometric designs were painted by the women on flat purses (5-Sioux) or cylindrical cases (6-Flathead) used to carry a warrior's headdress.

NETTING of rawhide strips was important among the northern Algonkians and Athabaskans for snowshoes (7-Chippewa) and for bags. In the Plains a game was played by throwing spears at webbed hoops rolled on the ground (8-Sioux).

SADDLES (9-Plains), **RATTLES** (12-Pawnee), **AND DRUMS** (13-Chippewa) were covered with rawhide. So were large wooden boats (14-Mandan). Apache cut designs in rawhide saddle bags (10). Cutout figures (11) were made for the Plains Sun Dance.

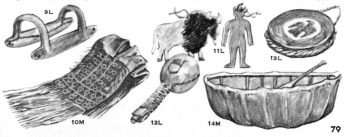

LEATHER is skin which has been tanned (p. 77) so it will stay soft and pliable. The term "buckskin" usually means smoked deer hide but many other skins (buffalo, antelope, elk) were also tanned by the Indians and used for clothing, bags, and tipi covers.

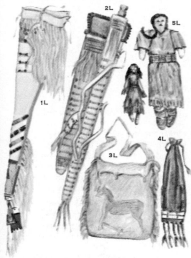

POUCHES AND SHEATHS of leather were prized by tribes in every area. The soft skin wears well and gives fine protection. Rifle scabbards (1-Crow) were decorated with beads and fringe. Bowcases and arrow quivers (2-Mandan) were often matched pairs like this quilled example of buffalo hide. Sacred medicine bundles were often kept in buckskin bags marked with a personal symbol (3-Crow), and smaller pouches (4-Plains) held tobacco, paint, or dice.

DOLLS (5) were made of skin and dressed in the skin costumes of the people. These Kiowa and Blackfeet dolls have real hair and wear authentic bead designs on belts and leggings.

BUCKSKIN DECORATION was done with beads, quills, and paint. Sleeveless Apache poncho dance shirts (6) are painted with bold angular designs. The Tlingit shirt (7) has sleeves, and a painted animal design. Tailored coats were found in the east. The soft, white Naskapi jackets (8) and coats are painted with clear, bright red and blue linear designs.

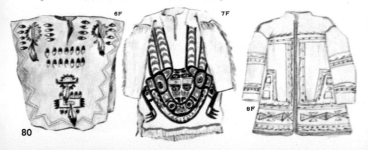

MOCCASINS were worn by many tribes, but the Indians on the Pacific Coast, even in the north, went barefoot and the Pima and Papago of the Southwest wore rawhide sandals like the Mexicans. Styles were adapted to the country and to the climate. Fur footwear was rare. In the winter some groups wore fur moccasins. Others stuffed their moccasins with grass.

THE SOUTHWEST AND SOUTHERN PLAINS MOCCASINS have rawhide soles stitched to buckskin uppers. Arapaho (1) and Comanche women's are knee-high and, like the Apache (2), can be turned down. Navajo (3) and Pueblo (4) men's moccasins are similar but Pueblo women (5) wear white moccasins with a wide strip wound around their legs up to the knee.

THE PLAINS MOCCASINS were once one piece with soft soles. Later styles have soft uppers and rawhide soles (9). Most are held on with a drawstring and have low cuffs. Some are beaded only on the toe (6-Blackfeet), others are beaded and painted (7-Osage), or completely beaded (8-Sioux) or quilled (10-Arapaho).

THE EASTERN WOODLANDS MOCCASINS are made from a single piece of leather (12). The cuff is often added and usually decorated (11-Winnebago). The style with inset vamp (13-Winnebago, 14-Chippewa) was found in the Northeast and Lakes areas. Winnebago women's moccasins (15) have a flap over the toe.

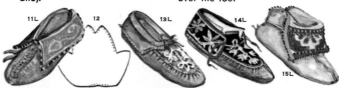

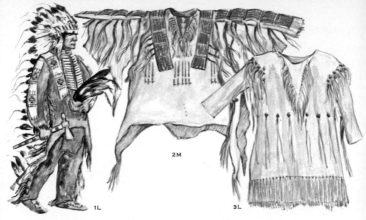

SHIRTS were once worn only by warriors on special occasions. Except in the north most men went naked to the waist and wore robes. The old style shirt (2) was a poncho with open sides. Two skins of deer, antelope, or mountain sheep were needed for a shirt; their natural shapes determined its form (4). During the 1800's shirts had sleeves, the sides were sewn, and the bottoms squared off (3-Cheyenne). They were beaded (1-Sioux), quilled (2-Sioux), painted (2), or decorated with hair, ermine, or with fringe (3-Cheyenne) typical of the Plains.

LEGGINGS were worn by both sexes: women's came to the knee, men's reached from heel to hip (1). They were buckskin tubes which fitted over the legs and tied to the belt. Each required the hide of a deer, antelope, or mountain goat. The rear legs became ties and, in some Plains styles, the neck skin made a trailing tab (5). One style had large side flaps like chaps, others were cut square at the bottom (6-Ute). Fringe and decorative strips of quill or beads were usual. Front seam leggings (7-Winnebago) fitted the leg with a flap over the foot (p. 63).

82

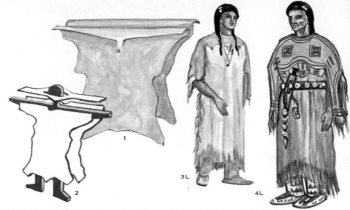

SKIN DRESSES were worn by the northern tribes. They were most typical of the Plains and Prairie women but occurred also in the eastern Apache and some of the Basin and Plateau tribes.

Plains dresses were made with two elk skins (1) sewn together. To straighten the shoulder line the tail end of the skins were folded down. When a yoke was added between the skins (2), the old pattern (3-Jicarilla) was preserved. Even the elaborate Sioux dresses (4) retained a loop where the tail once was. The Blackfeet (5) emphasized the pattern with rows of beads.

OLD STYLE DRESSES in the Northeast, Lakes area, and northern Plains were jumpers worn with separate sleeves (6-Plains Cree). A skin yoke or capelet was often worn over the shoulders. Made of trade cloth, the jumper persisted in the Lakes area until replaced by skirts and blouses. In the southern Plains the Cheyenne (7), Kiowa, and Comanche wore dresses sewn together at the waist. Mescalero and Chiricahua (8) Apache girls still wear two-piece white buckskin dresses, decorated with beadwork for their "coming out" ceremony.

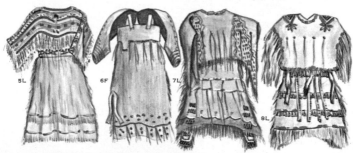

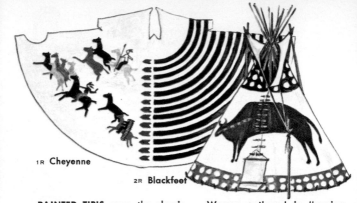

1R Cheyenne

2R Blackfeet

PAINTED TIPIS were the classic dwellings of the hunting tribes of the Plains. Skin tents were used by other Indians but they never rivaled the Plains tipis in beauty and symmetry. Tipis ranged from hunting tents 12 feet in diameter to camp tipis nearly 30 feet across with poles 40 feet long. An average tipi required 15 to 20 buffalo cow hides, but up to 50 might be needed for a large lodge.

Women gathered in "sewing bees" to help make a new tipi cover. As in all skin sewing no needles were used; holes were made with an awl (p. 125) and sinew thread was passed through them. A finished tipi cover weighed about 100 pounds. The paintings are ceremonial designs (1, 2). Three-pole foundations were used in the central Plains, four-pole foundations in the northwest Plains.

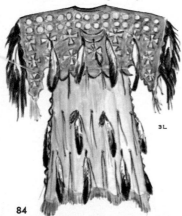

3L

PAINTED SKIN CLOTHING (3) was found most often in the Plains where the designs usually had ceremonial significance. (Examples of painted shirts from other areas are shown on page 80.) Some tipi covers, robes (p. 85), shirts, and dresses had conventionalized designs (1, 2 -p. 85), others depicted scenes from life (4 -p. 85), and some carried sacred symbols for protection. During the Ghost Dance rebellion in 1890 supernatural designs were painted on shirts and dresses (3-Cheyenne).

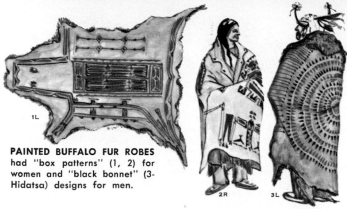

PAINTED BUFFALO FUR ROBES had "box patterns" (1, 2) for women and "black bonnet" (3-Hidatsa) designs for men.

FURS were used by the Indians primarily as robes, blankets, and decorations. In a number of areas strips of rabbit fur were twined into soft, fluffy robes (6-p. 57) and in the Plains buffalo robes were worn by both sexes. In addition to the conventionalized designs shown above the men painted "exploit" robes with naturalistic depictions of adventures in war (4-Crow). The skins were prepared with a coat of beaver tail glue and earth colors were applied with bone brushes.

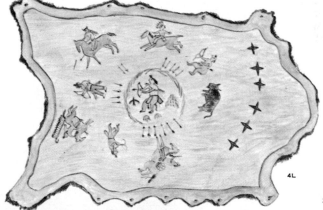

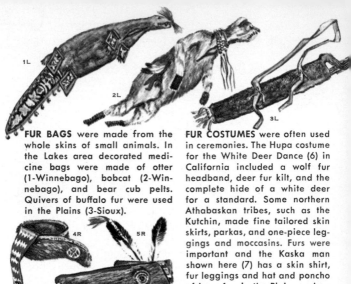

FUR BAGS were made from the whole skins of small animals. In the Lakes area decorated medicine bags were made of otter (1-Winnebago), bobcat (2-Winnebago), and bear cub pelts. Quivers of buffalo fur were used in the Plains (3-Sioux).

FUR HATS were common among the Lakes and Prairie tribes. Otter skin hats, decorated with beads or ribbonwork (4-Fox, 5-Pawnee), were for prestige.

FUR COSTUMES were often used in ceremonies. The Hupa costume for the White Deer Dance (6) in California included a wolf fur headband, deer fur kilt, and the complete hide of a white deer for a standard. Some northern Athabaskan tribes, such as the Kutchin, made fine tailored skin skirts, parkas, and one-piece leggings and moccasins. Furs were important and the Kaska man shown here (7) has a skin shirt, fur leggings and hat and poncho of bear fur. In the Plains and on the Northwest Coast, men wore ermine skin decorations on shirts and headdresses. The northern Chippewa women (8) wore mittens, fur-lined moccasins, and short fur capes.

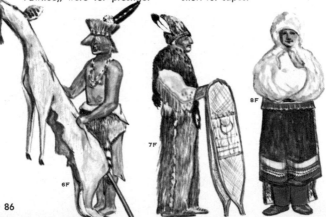

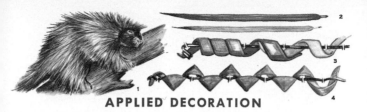

APPLIED DECORATION

Applied design was a favorite decoration. Materials used included quills, beads, ribbons, moosehair, and shells. Quillwork was native; beadwork and ribbon appliqué were done with materials from white traders.

PORCUPINE QUILLWORK was done only by the Indians. The porcupine (1) has smooth, shiny quills (2) up to five inches long. When soaked in water, they become flexible and can be bent and twisted.

NORTHEAST QUILLWORK was usually done by wrapping (3) or folding (4) quills around a single thread which was sewn to cloth or skin. The designs of the Iroquois (5, 7), Huron, and Algonkians (6) have a linear quality. Solid designs were common on ceremonial belts (8-Winnebago) and other articles. Northwest Coast quillwork was influenced by the east. Quills were wrapped on fringe and sewn on costumes (9).

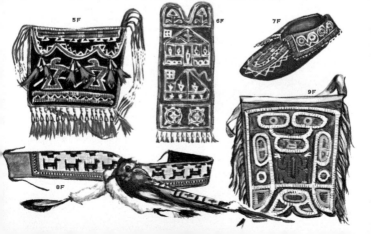

QUILLWORK ON BIRCH BARK spread from the Northeast to the Lakes area. Dyed quills were pushed through holes in bark boxes and bent on the inside. A lining concealed the ends and held them in place. Most boxes were made to sell. The Micmac and other Northeast tribes made vaulted boxes (2) with solid geometric designs and round and oval boxes (3) with simple floral patterns. The Ottawa and Chippewa of the Lakes area made round sewing baskets covered with naturalistic animals (1) and flowers or with solid quillwork (4). Open designs were also done on rectangular boxes (5).

WOVEN QUILLWORK is found chiefly among the Cree and Chipewyan of central Canada. It is the finest quillwork in North America. As a simple band is plaited on stretched fiber warps, soft, flattened quills are woven in and out of the wefts (6). The quills, pushed tightly together, give the appearance of small, cylindrical beads (7). Angular, geometric designs are woven on white backgrounds for belts (8), pouches, or decorations on skin.

EMBROIDERY done with moosehair and quills was probably introduced by the French. The Huron and Iroquois, especially, dyed the long hairs from the mane and rump of moose and embroidered designs on cloth moccasin vamps (9) and robes. Birch bark boxes (10, 11) were also decorated with moosehair; fiber tumplines were decorated in false embroidery (2-p. 63).

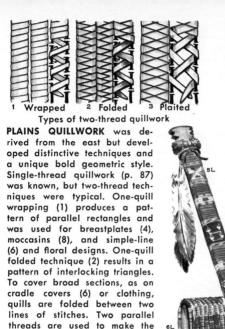

1 Wrapped 2 Folded 3 Plaited

Types of two-thread quillwork

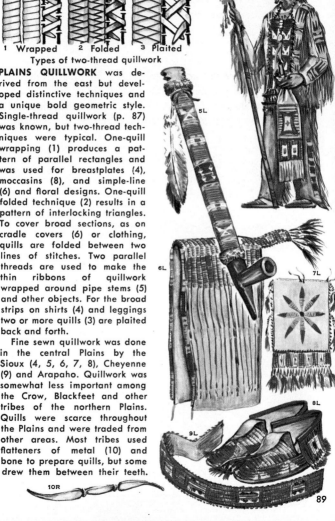

PLAINS QUILLWORK was derived from the east but developed distinctive techniques and a unique bold geometric style. Single-thread quillwork (p. 87) was known, but two-thread techniques were typical. One-quill wrapping (1) produces a pattern of parallel rectangles and was used for breastplates (4), moccasins (8), and simple-line (6) and floral designs. One-quill folded technique (2) results in a pattern of interlocking triangles. To cover broad sections, as on cradle covers (6) or clothing, quills are folded between two lines of stitches. Two parallel threads are used to make the thin ribbons of quillwork wrapped around pipe stems (5) and other objects. For the broad strips on shirts (4) and leggings (3) two or more quills are plaited back and forth.

Fine sewn quillwork was done in the central Plains by the Sioux (4, 5, 6, 7, 8), Cheyenne (9) and Arapaho. Quillwork was somewhat less important among the Crow, Blackfeet and other tribes of the northern Plains. Quills were scarce throughout the Plains and were traded from other areas. Most tribes used flatteners of metal (10) and bone to prepare quills, but some drew them between their teeth.

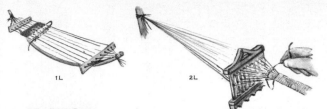

BEADWORK was best developed in the quillwork regions. Decoration with European glass trade beads began in the east about 1675. Techniques included weaving, netting, and spot-stitch and lazy-stitch sewing.

WOVEN BEADWORK is done with warp strands stretched as with a belt loom (p. 65) or on a frame or bow (1). Cross-warp weaving (3), with a wood heddle (2-Chippewa), introduced from Europe, separates the warps for insertion of the beaded weft. Other woven beadwork is done with a fine needle. In single-weft weaving (4) a thread with beads on it is plaited through the warps. For the common double-weft weaving (5) one weft strand is passed through the beads above the warps, the other below them. Woven bead-work tends to angular designs as in the shoulder bag (6-Chippewa), the sash (7-Winnebago), and the garter (8-Chippewa).

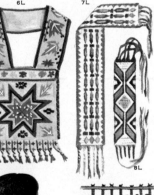

DIAGONAL PLAITING (10) is related to the sashes of the Lakes area (p. 62). The technique was used for beaded hair streamers (9) by the Menomini, Winnebago, Pottawatomi, Sauk, and Fox. They, and Prairie tribes, Oto and Osage, also wove hat and neck bands of horsehair.

SPOT-STITCH SEWING is done by laying threaded beads in a design and sewing them in place (4). It was used for complex linear designs in the Northeast and floral patterns in the Lakes area and northern Plains. Floral designs in the northern Lakes area are naturalistic and worked with concentric rows of shaded colors (1, 8).

To the south the Winnebago and Sauk designs (2, 9, 10) are stiff and filled in with straight parallel rows of beads. This style was adopted by the Prairie tribes. Chippewa men (3) wore spot-stitched leggings, floral shoulder bags and aprons, moccasins, and turban decorations.

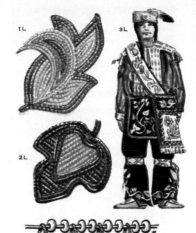

NORTHEASTERN BEADWORK is lacy, as shown by the Penobscot collar (5) and Iroquois woman's leggings (7). The Micmac panel (6) shows the stylized floral work of the area.

LAKES AREA BEADWORK is asymmetrical and naturalistic among the Chippewa (8). The Sauk pipe bag (9) and shoulder bag (10) show the bolder southern style of bilateral symmetry.

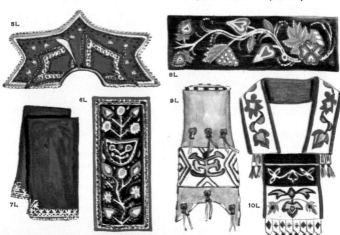

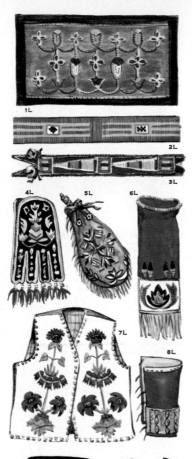

1L

2L

3L

4L 5L 6L

7L

8L

9F 10R

NORTHWESTERN SPOT-STITCH SEWING spread from the Lakes tribes across the northern Plains into the Plateau area and then north to the coast. It was used by the Blackfeet and Crow for geometric beadwork designs until about 1870 when floral motifs became the vogue. Checks, diamonds and terraced triangles were old patterns among the Assiniboin, Sarcee and Blackfeet (2), whose women's dresses (5-p. 83) and leggings (8) were beaded with geometric designs. The Crow emphasized simple triangular forms (3), often sewn on red cloth.

Floral designs may have been inspired by European embroidery. They appear in this area at the same time as the small "seed" beads (p. 93). Some designs use lines of beads, as in the Crow pipe bag (5); the Blackfeet saddle bag panel (1) and pipe bag (6) show a more formal style. The Plateau tribes developed the solid floral style shown on the Flathead vest (7). Cloth "four tab" bags, like the Nez Percé example (4), were widely traded and, with more naturalistic designs, were made also by the Athabascan tribes of western Canada.

NORTHWEST COAST BEADWORK was influenced by the Plateau area and the interior Athabascans. Beaded accents were added to hats and skin paintings. Designs of typical Northwest Coast type were stitched on panels for dance aprons, shirts (9-Tlingit), and on collars (10-Tlingit).

PLAINS LAZY-STITCH SEWING

(1) is characteristic of the work of the Sioux, Cheyenne, and Arapaho of the central Plains and the Ute of the Plateau. It is very effective for decorating large areas and for geometric designs. An appearance of parallel ridges results from sewing the beads in short rows fastened only at the ends. The usual beads are "seed" beads (2) which came into the Plains about 1840 and became popular 20 years later. The older "pony" beads (3) were used in simple patterns from 1800 on.

Typical geometric designs on white background are shown here on the Sioux saddle bag (4) and the pipe bag (5) with quillwork above the fringe. It is believed that these designs were from Oriental rugs of early settlers. The use of bands interspersed with small figures marks the Arapaho woman's leggings (6) and her "anything" bag (7). The Cheyenne cradle board (8), with blue beads used for background, is typical of the central Plains. In the southern Plains the Kiowa and Comanche used lazy-stitch. So did their neighbors, the Jicarilla Apache, but mostly on borders of clothing.

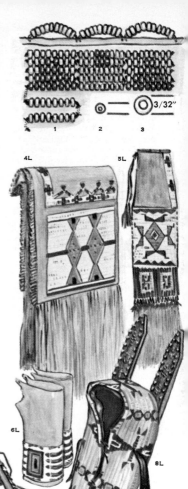

IROQUOIS EMBOSSED BEADING

is a type of lazy-stitch in which the arching of the stitch is emphasized by crowding the beads and raising the designs with padding. It was sometimes combined with spot stitching on moccasins (1) but was used especially for decorating velvet pouches (2) with floral designs and for men's caps (3). Pony beads (3-p. 93), often translucent, were used between 1860 and 1890 on articles for the tourist trade.

NETTED BEADWORK (4, 5, 6)

is done in a variety of ways to produce netting in which beads take the place of knots or loops. It is widely used to cover rounded surfaces, as on Washo baskets (5-p. 49). The handles of the Winnebago Peyote fan (8) and rattle (9), used today in religious ceremonies by many tribes, are beaded in the "gourd stitch" technique (6). Apache women's collars (11) are also made with this technique, which produces a solid beaded surface. The loose openwork technique (4) which looks like netting was used best by the Mohave and by some Paiute for large cape collars (7-Mohave). The California Modoc made collars and the Comanche made pouches (10), cradles, and other articles.

The southern Plains (Comanche), the Colorado River (Mohave, Yuma), and parts of the Basin-California border were the areas in which netted beadwork was important but it was widely scattered. Peyote ceremonial pieces decorated with it were traded among many tribes.

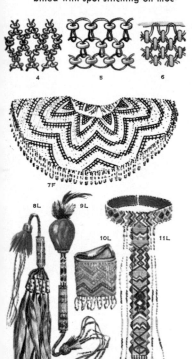

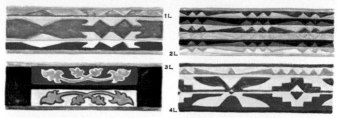

APPLIQUE decoration is done by cutting cloth or ribbon into designs and sewing the patterns onto leather or textile of a different color. In some cases, a block or strip of one color is sewn on another; in others, the patterns are very complex with two or more layers of different colors sewn on top of each other.

RIBBON APPLIQUE is used to decorate cloth by sewing on colored ribbons of silk or satin cut into elaborate designs: floral shapes (3) and mosaics of angular forms (2), some with openings to show underlying colors (1). Ribbons are used most to decorate women's robes and skirts (5, 6).

Ribbonwork came into use about 1780 among the southern tribes of the Lakes area (2-Menomini, 3-Sauk, 4-Winnebago, Pottawatomi); also developed by the Oto, Osage (1) and other Prairie area tribes. Some ribbonwork was done in the Southeast and the Iroquois combined it with beaded designs.

Clothing was decorated with ribbon appliqué. Women's robes were bordered (5-Menomini, 6-Osage) and skirts were decorated with a center panel of color (5). Men's and women's leggings and moccasins were decorated with ribbonwork (7-Sauk, 8-Winnebago).

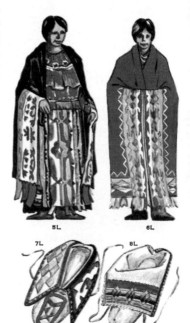

95

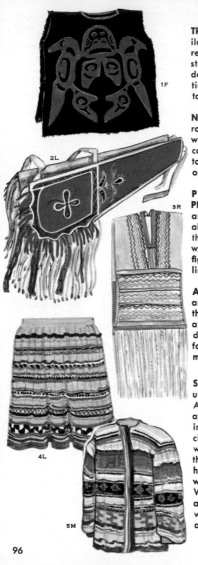

TRADE CLOTH APPLIQUE is similar to ribbonwork but employs red and blue woolen fabrics instead of silk. It was used to decorate clothing and other articles. Colored ric-rac is used today by the Apache.

NORTHWEST COAST shirts and robes (1-Haida) were decorated with totemic figures cut out of colored cloth. White shell buttons were sometimes used to outline the designs.

PLATEAU AND NORTHERN PLAINS tribes made dresses and shirts of trade cloth. They also covered skin articles, like this Blackfeet horse crupper (2), with cloth and sewed on cloth figures of different colors outlined with beads.

APACHE RIC-RAC (3) is not an ancient art. Like many people, the Apache buy colored ribbons and sew them on dresses, saddlebags (3), and other articles for bright decoration. Sewing machines are used.

SEMINOLE PATCHWORK is unique among Indians of North America. Patchwork displaced appliqué about 1910. The Seminoles have used sewing machines since 1890. The men wore a "big shirt" which reached the knees. Short shirts (5) have been used since the 1930's when the men adopted pants. Women's traditional skirts (4) are long and very full. They are worn with a loose overblouse and many strings of beads.

96

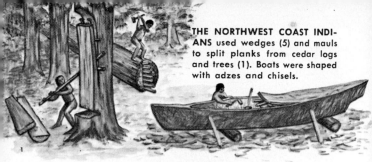

WOODWORK

Wood and bark were important to all the Indians. Both were used for houses as well as for numerous utilitarian and ceremonial articles. The Northwest Coast Indians, particularly, became highly skilled in the art of woodworking and in carving.

WOOD is often hard or has a fibrous grain that can be cut only with a sharp blade and so it was difficult to work without metal tools. Many tribes used fire to fell trees; some, like the Seminole and Haida, burned out parts of their dugout boats.

WOODWORKING TOOLS, such as these Northwest Coast adzes (2, 3) for shaping and carving, had stone or shell blades before the traders brought iron. D-shaped hand adzes (4) were used for fine finishing. Chisels (6) with stone mauls (7) were also used. For many tribes, especially in the Lakes area, the most useful woodworking tool was the "crooked knife" (8).

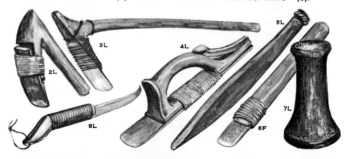

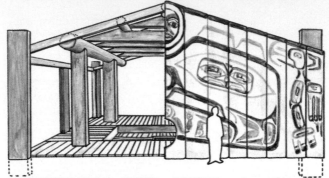

NORTHWEST COAST HOUSES reflected the Indians' skill in woodworking. They were built with thick planks and massive beams sometimes fifty feet long with a shed or gabled roof. The roof, of overlapping planks, was supported by a frame of posts and beams which was built to stand for years. The plank walls formed a simple shell which could be removed or replaced when boards rotted or the tribe moved. Many families lived in a house with each apartment on the platform separated by mats or partitions of wood.

DUGOUTS on the northern part of the Northwest Coast are high at each end (2); the Nootka type (3) is built with a straight stern. Hupa and Yurok boats (1) are square at both ends. Small "shovel nose" dugouts (5) were also used on the west coast. On the Atlantic Coast, the dugouts were simple and rounded-ended (6) and the Seminole (4) still make slender boats with stern platforms for poling. All Indians used paddles: some were pointed, others were shovel-shaped, and many were painted or carved.

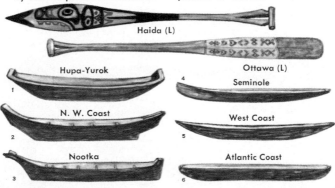

Haida (L)

Ottawa (L)

Hupa-Yurok
1

N. W. Coast
2

Nootka
3

Seminole
4

West Coast
5

Atlantic Coast
6

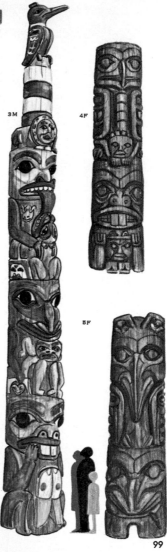

NORTHWEST COAST RITUAL CARVINGS represent the peak of wood carving. Many people participated in the rituals, and various articles such as "power boards" facilitated their relationships with the spirits of the other world. This Kwakiutl board (1) represents the double-headed serpent which protects warriors. The simpler spirit canoe boards of the Salish (2) were set up by the shaman as he ritualized his journey to find a patient's soul.

TOTEM POLES AND HOUSE POSTS of the Northwest Coast depict supernatural and legendary characters. Some are ancestors, others recount a story or an event in clan history. Particular features identify the characters: the bear is recognized on the Haida pole (3) by his protruding tongue and the beaver by his two large incisor teeth. Such poles commemorate great events—deaths, births or victories. House posts, like these Haida examples (4, 5), are carved in the same manner and are often painted.

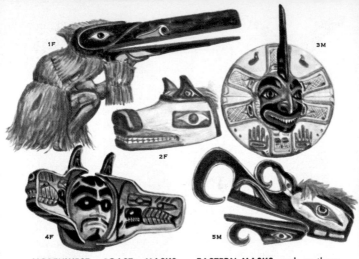

NORTHWEST COAST MASKS

were worn in ceremonial dances to recount legends and celebrate rituals. The Hokhokw bird mask (1) and the Crooked Beak mask (5) were used by Hamatsa, the so-called Cannibal Society. The Killer-Whale-on-the-Sun mask (3) and the Deer mask (4) belonged to the Laolaxa Society. Moving beaks and double faces (4) operate with strings. These are Kwakiutl. Some masks, such as the Nootka Wolf mask (2), are worn on top of the head.

EASTERN MASKS, such as those

excavated at Key Marco, Florida, were once equal to those of the Northwest. The Iroquois still wear false faces in healing rituals. They are carved from a living tree and often depict "The Great One" (6) with his broken nose. The Seneca buffalo mask (7) appeared about 1900 but the Cayuga-Onandaga "divided mask" (8) is old and may have come from the Delaware. Cherokee "Booger" masks (9) are evil aliens.

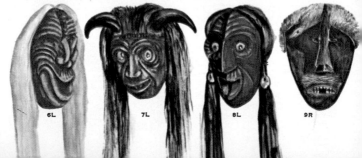

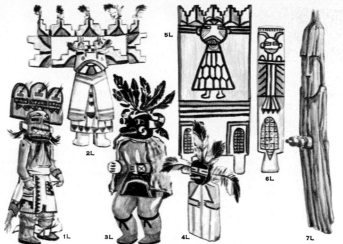

PUEBLO CARVING was confined to ritual figures. Kachina dolls represent the gods; are used to teach religion. Zuni dolls (1) are slender, with movable arms and cloth kilts. The Polik Mana doll (2) shows the simple Hopi style; the Black Ogre (3) is modern and more realistic. Flat dolls (4) are hung on cradles. Kachinas and corn symbols are painted on dance plaques (5) and "prayer sticks" (6). Simple Zuni "war gods" (7) were left as offerings at shrines.

EFFIGY FIGURES were generally for ritual purposes. On the Northwest Coast jointed puppets (8) were used in conjuring but the function of the little (7-inch) bear (9) is not known. In the Lakes area the Chippewa carved "love dolls" (10) and figures with cavities for ritual materials (12). Hawk (11) and owl (13) effigies were placed on Chippewa graves. The prehistoric Calusa cat figure (14) is an example of the fine carving once done in the Southeast.

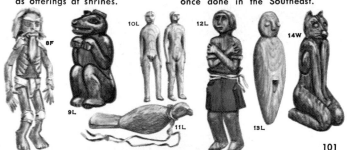

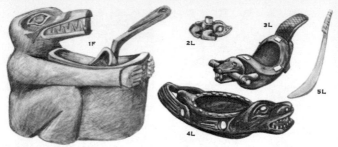

WOOD UTENSILS on the Northwest Coast were usually decorated with carving. The large feast bowl (1) depicts a bear and the ladle a crane. The little frog figure (2) is a pipe. Effigy dishes like the beaver (3) and seal (4) were eating bowls. Spoons were decorated, with family crests on the handles (5).

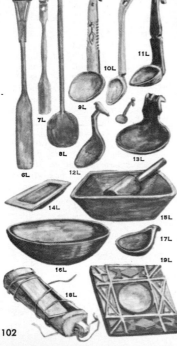

STIRRING PADDLES AND LADLES were made in the Plains and Prairies and stirring paddles were common among the Yurok (8) and other California tribes, but they are also typical of the Lakes area and the Northeast. Here paddles for maple syrup making (6) were often decorated with figures (7). Large ladles (9, 10, 11) were household items and also used for feasts. Smaller spoons (12, 13) were usually personal items, hung from the owner's belt.

WOOD DISHES were carved out of hard woods (14, 15) and some fine bowls were carved from maple and walnut burls (16, 17). The rough forms were shaped with an axe and the rest of the carving was done with a "crooked knife" (8-p. 97).

Chests were rare but boxes with lids (18-Pueblo) were made by many tribes. Tobacco cutting boards (19-Plains) were often carved and painted.

DRUMS are usually wood although only the Northwest Coast box drums (1) are all wood; the others have skin heads. The Pueblos (2) use sections of large hollow logs. The big ceremonial Chippewa drums (6) and their smaller Midé water drums (4) are made with hollow logs or wood kegs. The Iroquois also made water drums (5) with plugs to change the level of the water and the tone of the drum. Most tribes made shallow drums (3) with bent wood sides. Snare drums had a tight string inside.

FIDDLES (11) were adopted by the Apache from the Mexicans. They have a body of maguey stalk and a single string.

FLUTES AND WHISTLES were widely used; decorated cane flutes (12) were unique among the Yuma, as was the double whistle (13) on the Northwest Coast. End flutes were played in the Lakes (14) and Plains (15) areas, particularly for love songs. They have two chambers.

WOOD RATTLES of two glued pieces were carved by the Northwest Coast tribes (7, 9) and the Iroquois (8). Clappers (10) were common in California.

BOWS of yew and other hard woods were often decorated (1-Mohave). The Penobscot bow (2) was unique. Some bows had sinew backing (3-Yurok) or inserts (5-Mandan) for extra power. Arrows were straightened with bone wrenches (p. 128) or in heated stone forms (4-California). Blow guns and darts (6) were used by the Cherokee and the Iroquois.

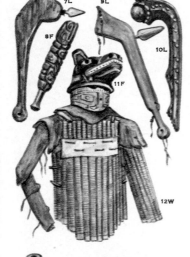

CLUBS were used in all areas but the classic ballhead club (10-Sioux) of the eastern tribes and the Plains was probably the original "tomahawk." Many clubs had spikes of bone or metal (7). The Papago used a "potato masher" club and the clubs of the Northwest Coast were carved (8). The gunstock form (9-Chippewa) was common.

ARMOR made of wood slats and heavy skin (12) was worn on the Northwest Coast with ornately carved helmets (11).

PIPE STEMS range from simple tubes to ornately carved. Flat "puzzle stems" (13-Chippewa) are pierced with designs. Many medicine pipes have corkscrew stems (14-Chippewa) or are carved (15-Pawnee).

BABY CARRIERS of wood were made like boxes on the Northwest Coast (1) and often painted and carved. Apache carriers (2) are made of slats bound on a hoop. Eastern forms consist of a board with a face guard and footrest. Iroquois footrests (3) are solid steps: the Algonkian forms (4-Chippewa) have bent boards laced in position as a footrest.

BACKRESTS (5-Blackfeet) and beds of smooth willow rods lashed together with sinew were used by most of the Plains tribes. Backrests, decorated with beadwork, were supported by a tripod of poles with carved designs. Furs were thrown over the rest for comfort.

CEDAR-BARK SHREDDERS (6) were used on the Northwest Coast to beat the stiff bark until the fibers were softened.

MAT CREASERS (7) were pressed over cattails by the Salish to make a ridge through which a bone matting needle (p. 125) could be passed.

FISHING GEAR was often of wood. Northwest Coast halibut hooks were made of two pieces (8) or of a bent shank (9) with bone barbs. Straight hooks (10) were common. In the Lakes area lures (11, 12) were bobbed in the water to attract fish to be speared.

105

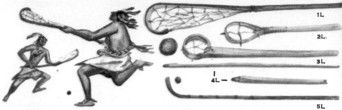

1L

2L

3L

4L —

5L

GAMES were played by both sexes. Most eastern tribes played lacrosse; the Iroquois used a large hook-shaped racquet (1), the Southeastern tribes two sticks with small nets (2), and the Lakes tribes single sticks (3-Winnebago). Snow snakes (4) were thrown for distance by the Iroquois and western tribes. Shinny, played with a curved stick (5-Mohave) and a ball, was a popular sport from the Plains to the coast.

6F

TOBOGGANS (6-Algonkian) were used by the northern Indians from Labrador to the Yukon. They were made in different sizes but all consisted of smooth planks curved upward at the front end.

NORTHWEST COAST BOXES served for cooking, storage and burial. Oil or food boxes (7) were trimmed with shell. Many chests (8) were carved and painted, others (9) were only painted. The sides were made from a single plank which, adzed thin and smoothed with a stone or shark skin, was steamed and bent into a rectangle. Grooves inside the corners facilitated bending. The joints were sewn with spruce root or closed with small wood pegs.

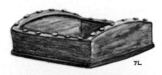

7L

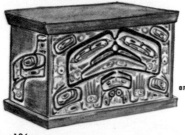

8F

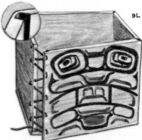

9L

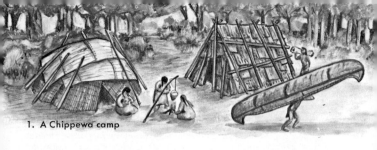

1. A Chippewa camp

BARK was one of the most important materials available to the tribes of the northern woodlands. Birch bark was used by the Algonkian tribes from the Atlantic to the Mississippi and by the Athabaskans into Alaska. The Iroquois made good use of rough elm bark (p. 108) and houses were built with it in the Mississippi Valley. White pine bark canoes were made by the Kutenai (p. 110).

HOUSES were covered with mats and sheets of bark throughout the east and in parts of the west coast. The tribes of the Lakes area sewed sheets of birch bark into long rolls to cover their hemispherical wigwams (1) and tent-shaped lodges (1). In the Northeast area birch bark was used to cover the small conical wigwams of the Naskapi (2).

Tribes of the Southeast area built arch-roofed houses covered with mats and sheets of bark (3). In the Lakes area and the Prairie area large rectangular houses with gabled roofs (4) were covered with heavy elm bark. These were the summer lodges of the Sauk and Illinois, and of the Sioux before they moved to the Plains. The famous long houses of the Iroquois (5) were also covered with elm bark.

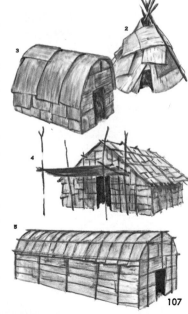

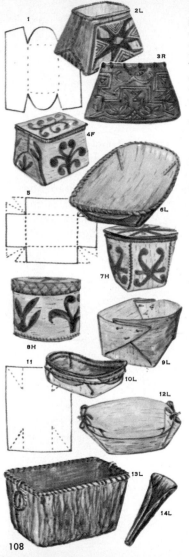

BARK CONTAINERS serve many uses and are made in many shapes: buckets (2), boxes (4), trays (6), bowls (10), and cups. There are four basic patterns: end sewn (1), corner sewn (5), cylindrical (8), folded (11). The cutout pattern is softened with heat, bent into shape, and sewn with wood or root fiber through holes made with a sharp awl (p. 131). The Chippewa seal the seams of *mocoks,* or buckets (2), with pitch or balsam gum.

Decorative designs are engraved in the soft bark (3-Penobscot) by eastern tribes or, more generally, scraped through the thin brown inner coating found on birch bark gathered in the spring (2-Chippewa). Sometimes the coating is removed to leave dark designs (4-Micmac). Geometric patterns and naturalistic motifs of plants, animals, and men are drawn.

Trays for winnowing wild rice (6-Chippewa) and some deep storage containers (7-Cree) are corner sewn. Cylindrical boxes with lids (8-Naskapi) are made of a strip of bark.

Watertight pans to catch maple sap and for cooking are made quickly by folding birch bark and sewing (9-Penobscot) or tying the ends (12-Chippewa).

The Athabaskan tribes of the Subarctic area make fine watertight birch bark bowls (10). The sides are held in place with a wood splint. The rims are often decorated with plaited checkered designs.

The Iroquois used rough elm bark to make buckets (13), rattles (14), and even canoes.

BIRCH BARK CUTOUT FIGURES (1-Chippewa) are made by the women of the Subarctic, Lakes, and Northeast areas. Their outlines are traced to make engravings on bark or for beadwork designs. The Athabaskans sewed them on bark containers. Many were never used but kept for pleasure and amusement.

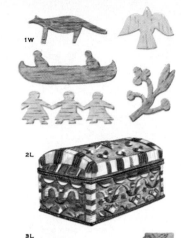

BIRCH BARK DECORATION with colored porcupine quills (2-Micmac) is described on p. 88. Designs were also applied with moose hair, and root fibers, dyed bright colors, were used for stitching and for binding the rims. The Chippewa frequently sewed a coil of sweet grass on the rims.

PICTURE WRITING was highly developed by the Chippewa. Pictures were drawn to preserve ceremonial details, or to record a dream (4). Long (36-inch) birch bark rolls (5) were engraved with symbols to preserve ceremonial information of the Grand Medicine Society, the Midéwiwin, dedicated to religious healing and the preservation of health. Members paid their way through various ranks. The scrolls are bound at the ends with wood splints. The designs are pressed into the soft inner bark with a bone point and rubbed with vermillion.

BIRCH BARK TRANSPARENCIES (3-Chippewa) are a form of pure art practiced by Chippewa and Algonkian women. Paper-thin bark is folded and bitten to make designs that show clearly when held up to the light.

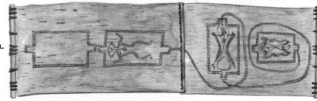

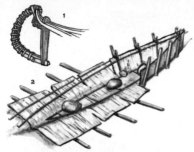

1

2

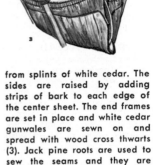

3

CANOE MAKING among the Chippewa is supervised by an expert; the women sew and men do the woodwork. It takes two weeks to make a 15-foot canoe. The center sheet of birch bark is spread out and held down under a wood canoe form (2). The edges of the bark are turned up between "guide posts" and held with cedar stays. End frames (1) are bent from splints of white cedar. The sides are raised by adding strips of bark to each edge of the center sheet. The end frames are set in place and white cedar gunwales are sewn on and spread with wood cross thwarts (3). Jack pine roots are used to sew the seams and they are coated with pitch. Thin cedar boards, soaked to make them pliable, are set in place for floor boards.

Ribs are made of cedar strips softened in hot water and U-shaped. After being set and allowed to dry for a day they are hammered into place (4). This is done with great care to keep the bark from splitting. To finish, a root strip is sewn along the prow seam, a guard strip is placed over the gunwales to protect the stitching, and all cracks and holes are filled with pine pitch.

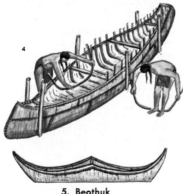

4

5. Beothuk

7. Dogrib

6. Micmac

8. Kutenai-Salish

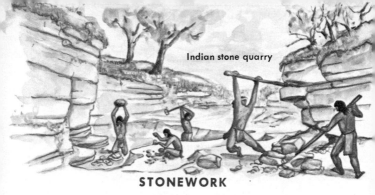

Indian stone quarry

STONEWORK

Stone, prehistoric man's basic tool material, was used by all the Indians. No other material was as important for weapons and hunting implements and it was widely used for ornaments such as beads, pendants, and earrings. Some kinds of stone are more attractive in color and texture or more easily worked than others; these were in such demand that they were traded over enormous distances. Shiny, black obsidian, from the Rocky Mountains, was traded to the Mississippi Valley, and finished objects or raw material from the catlinite pipestone quarries of Minnesota and the brown flint deposits of western Tennessee have been found thousands of miles from their natural origin. On the west coast and in the southeast, deposits of steatite were worked. Although tunnels were occasionally dug, most mining was done in open quarries.

BREAKING STONE into workable pieces was usually done at the quarry. Many flints occur in rounded nodule form and were broken into convenient pieces with hammerstones or mauls. Limestone and catlinite, which occurs in layers, were uncovered and pried out.

CHIPPING techniques were used to shape flint and other dense, smooth-textured stones into weapons and tools. Techniques are described below.

PERCUSSION CHIPPING knocks off flakes with a sharp blow. The direction and force of the blow determines the size and

shape of the flake. Stone and antler hammers are used in direct percussion (1). A rest (2), to hold the flint in place, improves control. Indirect percussion (3) is used to strike off long blades with accuracy.

PRESSURE CHIPPING is used to shape and finish fine stone implements. A chipping tool of bone or antler (4) is pressed against the edge of the flint, breaking a small flake from the opposite surface (5). A crutch (6) may be used for increased pressure.

Secondary flaking is a finishing process (7). Rough pieces are retouched to even the edges and to give the blade a uniform thickness.

Pressure finishing is also used to form notches and barbs. The point may be held in the hand (7) or on a support (8) with a cushion of leather used for protection.

Nibbling with a notched antler (9) or prong (10) removes minute flakes from the edges of points and knives.

PROJECTILE POINT TYPES

1. **CLOVIS**, Palaeo-Indian, 15,000-10,000 B.C. SW and Neb., circa 3".

2. **FOLSOM**, Palaeo-Indian, 8000 B.C., Tex. to Alberta, circa 2".

3. **SCOTTSBLUFF**, Palaeo-Indian, 7000 B.C., Tex., Ark., to Saskatchewan, 3-4".

4. **SCOTTSBLUFF-EARED**, Palaeo-Indian, 7000-5000 B.C., Wis., 2-4".

5. **OSCEOLA**, Old Copper Archaic, 5000-3000 B.C., Wis., Ill., Mo., 3-9".

6. **AFTON**, Archaic, 3000 B.C., Okla. to Ohio, 2-4".

7. **EVA**, Archaic, 5000-1000 B.C., Central Miss. Valley, 2-4".

8. **COPENA**, Early Woodland, 200-800 A.D., Central Tenn. River Valley, 3-4".

9. **ADENA**, Early Woodland, 800 B.C.-800 A.D., Upper Ohio Valley, 3-5".

10. **HOPEWELL** or **SNYDERS**, Middle Woodland Hopewell, 500 B.C.-500 A.D., Miss. Valley, circa 3".

11. **HOHOKAM**, Colonial and Sedentary periods, 600-1400 A.D., Ariz., 2-4".

12. **PUEBLO**, Periods I and II, 700-1050 A.D., Ariz., N.M., Colo., circa 1".

13. **CALIFORNIA OBSIDIAN**, Late Period, 250-1750 A.D., Central Calif., 2-3".

14. **CATAHOULA**, Plaquemine (Natchez), 1200-1600 A.D., La., Ark., circa 1".

15. **HAYES**, Early Miss. (Caddoan), 800-1200 A.D., Okla., Ark., La., Tex., 1-2".

16. **MORRIS**, Miss., Early Caddo, 800-1400 A.D., Okla., Kan., Mo., Ark., 1".

17. **CAHOKIA NOTCHED**, Late Miss., 1000-1700 A.D., Upper Miss. Valley, 1".

18. **MIDDLE MISSISSIPPI**, Protohistoric tribes, 700-1700 A.D., La. to Great Lakes, circa 2".

19. **COLUMBIA RIVER GEM POINTS**, 500-1750 A.D., Wash. and Oreg., ½-1".

20. **NODENA**, Early Quapaw, 1400-1700 A.D., eastern Ark., circa 2".

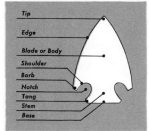

Tip
Edge
Blade or Body
Shoulder
Barb
Notch
Tang
Stem
Base

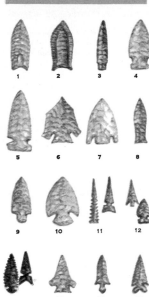

1 2 3 4

5 6 7 8

9 10 11 12

13 14 15 16

17 18 19 20

113

1L 2L 3L 4L 5L 6L 7L

POINTS AND BLADES were generally set into a slot which varied in depth according to the shape of the stone. The binding material was usually wet sinew which hardened and tightened as it dried.

Projectile points with side notches (1) or expanding stems can be hafted in a shallow slot. Those with parallel-sided stems (2) and unstemmed points (3, 4) need a deeper slot to keep them in place.

Drills (5) are hafted in the same way and some are set into sockets (6). In California the bindings were often coated with bituminous pitch (7).

CELTS, SCRAPERS, AND KNIVES were often made by chipping. Long, narrow chisels (8) and ovoid celts (9, 10) were chipped from flint and similar stone, and their bits ground and polished. They could have been hafted as axes or adzes.

Blades sharpened on the ends can also be used as scrapers or knives. Large and small flakes with fine chipped edges were often held in the hand (12) or set in wood handles. Scrapers could be hafted in line (11) like this double-ended Maidu example or they could be hafted at an angle (13) as in the skin fleshers of the Plains.

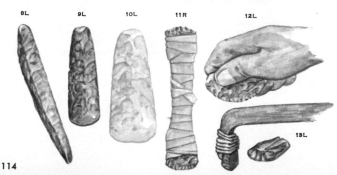

8L 9L 10L 11R 12L

13L

CEREMONIAL BLADES have been found often in the great mounds of the Southeast. Large batons or maces (1, 2) come from Spiro, Oklahoma, and Moundville, Alabama. Hook-shaped (3) and axelike (5) scepters appear on engraved shell gorgets (p. 138) carried by gods or dancers. The long, slender blades (4) are among the finest chipped stone implements in the world. Some are a yard long, about an inch wide, and only a quarter of an inch thick. They were probably carried in ceremonies and buried in caches at funerals.

THE UPPER MISSISSIPPI VALLEY Woodland Culture (1000 B.C.-100 A.D.) made fine knives and spear points (6).

NORTHERN CALIFORNIA was the center of a ceremonial complex in which wealth, represented by obsidian blades (7), woodpecker scalps, and shell money, was the goal of life. The Hupa and Yurok carried these blades in ceremonies such as the White Deer Dance (6-p. 86).

CHIPPED STONE HOES were used throughout the east to cultivate gardens and dig the foundations for houses. They are made of fine flint and their ends have a glossy polish from use. Some were hafted at right angles (8), others were hafted in a straight line (9) and used as hoes, spades, or posthole diggers. The notched type (10) could have been hafted in either manner.

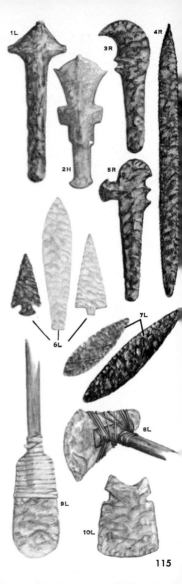

PECKING AND GRINDING techniques were used to shape many kinds of stone which are difficult or impossible to chip: sandstone, slate, granite, quartzite and many others. A piece approximately the required size is knocked off a block (1) or a nodule, or a river pebble is selected. It is then roughed out to shape (2).

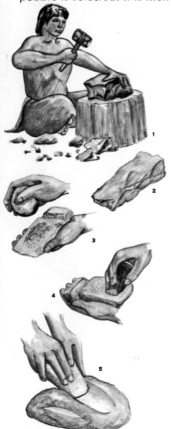

PECKING (3) the surface with a hammer stone slowly shapes the tool. This process of abrasion requires more patience than skill as the worker pulverizes the surface and pits it.

GRINDING down the rough surface is done by rubbing with a block of sandstone (4) or other abrasive. Sand and a piece of skin are used to give the final shape and finish.

SHARPENING and finishing is often done by rubbing the tool on a rough abrasive surface (5), such as a sandstone slab.

POLISHING is done with a whetstone (6) of fine sandstone or other abrasive. A piece of damp leather and sand provided a primitive sandpaper and, in the coastal areas, sharkskin was used for shaping and finishing. Many artifacts of slate are highly polished. Even granite is often rubbed to a glassy finish.

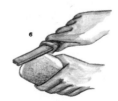

DRILLING AND CUTTING stone require time and patience. Some stones, such as basalt, are extremely hard and can only be abraded slowly. Other stones, such as catlinite and argillite, are quite soft when first uncovered and harden gradually. In their soft state they are easily worked.

DRILLING with a hand flint drill (1) in materials like sandstone makes a conical hole. A hole from the other side produces a biconical opening (5).

BOW DRILLS (2) are an ancient device. As the bow moves back and forth, the string twisted around the drill turns it around.

PUMP DRILLS (3) were used by the Pomo and other California tribes and in the Southwest area are still used to drill beads. A spindle whorl acts as a flywheel and gives momentum.

HAND DRILLS (4) were rotated between the hands. Hollow drills (6) made cylindrical holes. Some were only reeds rotating with sand; others had a strip of copper fastened around a shaft.

CUTTING stone was done by rubbing with sand (7). Chisels (8) can be used only in soft materials like steatite.

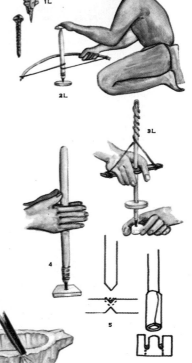

117

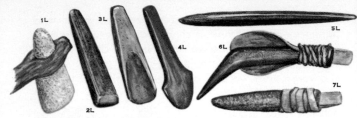

CELTS are often called ungrooved axes and some were certainly hafted (1) and used like axes. Pecked celts with pointed polls (1) are found in early cultures in the Southeast. Many Mississippi Culture celts (2) are smoothly finished and almost rectangular in cross section. The only gouges (3) are found in early cultures of Maine. The polished spud-shaped celts (4) may be ceremonial and related to similar types (p. 123). Long, double-ended chisels (5) are most typical of the Northwest Coast.

SCRAPERS, or hand adzes, with stone handles (6, 7) were used by the Yurok. The leather flap protects the knuckles.

GROOVED AXES are designed to be hafted. Full grooved forms (8) are hafted with wood strips bound into a handle. On some the edges of the groove are ridged or flanged (9). Axes with a three-quarter groove (10) are made for T-shaped handles as shown on the fluted axe (11), a type unique to the western Lakes area. The adze (12) with a single beveled bit is rare, and perforated mauls (13) are found only on the Northwest Coast.

CEREMONIAL MONOLITHIC AXES are found in the Southeast (14) and on the Northwest Coast (15). A distinctive "slave killer" effigy axe (16) was made in northern California. Rare.

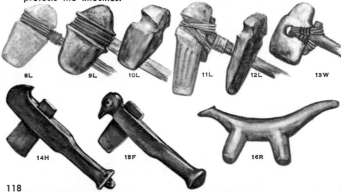

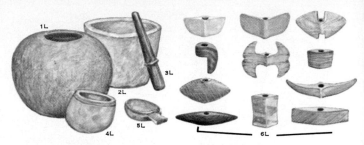

STONE VESSELS were made in many areas but were most common in California and the Southeast. The Chumash of southern California made large, thin-walled, globular pots (1) of steatite and flaring sandstone vessels (2) used as mortars with long pestles (3). Dippers (5) were common. In the Southeast many stone bowls (4) were made.

GORGETS, PENDANTS, AND BOATSTONES (7) are finely polished ornaments. Gorgets, common in the east, are flat with two biconical holes (5-p. 117). Pendants with single holes were made in many shapes but the hollowed-out "boatstones" from early cultures are enigmas.

BANNERSTONES (6) have always fascinated collectors. Some are drilled from edge to edge with a hollow drill (6-p. 117). Their function was long a mystery, but some are now known to have served as weights on early spear throwers (p. 129).

BIRDSTONES (8) **AND BAR STONES** (9), found from the Tennessee to the St. Lawrence, are beautifully made but their shapes and the purpose of two holes never explained.

BEADS are made of many stones. The best known are the magnesite money beads (10) of the Pomo and the fine turquoise (11) of the Southwest.

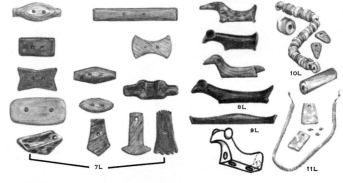

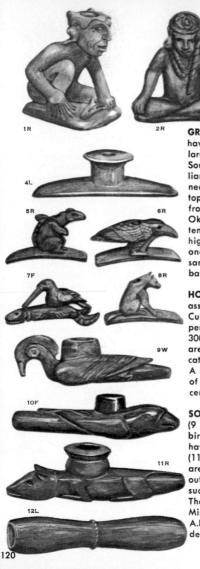

GREAT EFFIGY PIPES (1, 2, 3) have been discovered in the large temple mounds of the Southeast area. They are brilliantly carved and have connecting holes in the back and top. These three examples are from the great mound at Spiro, Oklahoma. The middle pipe is ten and three-fourths inches high and weighs eleven and one-half pounds. It is made of sandstone; the others are of bauxite.

HOPEWELL PIPES (4 to 8) are associated with the Hopewell Culture of the Middle Woodland period in the Ohio Valley (circa 300 A.D.). Some platform pipes are plain (4), others have delicate and natural animal effigies. A slender hole connects one end of the base with the bowl in the center.

SOUTHEASTERN TUBULAR PIPES (9 to 11) depict a variety of birds such as ducks (9) and hawks (10) as well as wolves (11) and other animals. Some are 16 inches long. Tubes without bowls (12) were probably sucking tubes for curing rites. They are part of the complex Mississippi Culture (700-1700 A.D.) and reflect a high artistic development (p. 123).

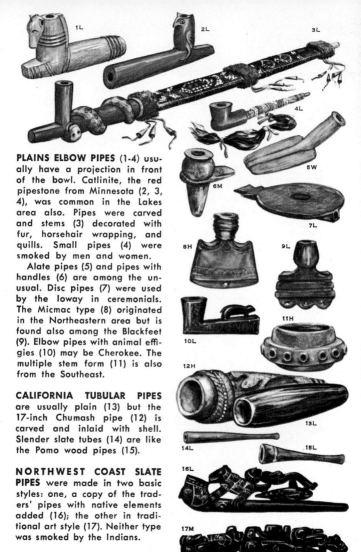

PLAINS ELBOW PIPES (1-4) usually have a projection in front of the bowl. Catlinite, the red pipestone from Minnesota (2, 3, 4), was common in the Lakes area also. Pipes were carved and stems (3) decorated with fur, horsehair wrapping, and quills. Small pipes (4) were smoked by men and women.

Alate pipes (5) and pipes with handles (6) are among the unusual. Disc pipes (7) were used by the Ioway in ceremonials. The Micmac type (8) originated in the Northeastern area but is found also among the Blackfeet (9). Elbow pipes with animal effigies (10) may be Cherokee. The multiple stem form (11) is also from the Southeast.

CALIFORNIA TUBULAR PIPES are usually plain (13) but the 17-inch Chumash pipe (12) is carved and inlaid with shell. Slender slate tubes (14) are like the Pomo wood pipes (15).

NORTHWEST COAST SLATE PIPES were made in two basic styles: one, a copy of the traders' pipes with native elements added (16); the other in traditional art style (17). Neither type was smoked by the Indians.

HOHOKAM STONE CARVING
was probably influenced from Mexico but these prehistoric people of southern Arizona developed their own style. Their favorite stone was a fine sandstone to make flat trays or paint palettes (1) decorated with lizards or geometric patterns. They are about 10 inches long. A variety of bowls were made, some carved with human (2) or animal (4) figures. Fine stone mirrors with iron pyrite mosaics (3) were probably traded from Mexico. The effigy figure of a kneeling person (5), possibly holding a bowl, is similar to those from other areas. Large stone knives (6) were apparently once covered with decorative mosaic designs.

COASTAL CALIFORNIA produced some fine stonework. The Gabrielino carved excellent fish effigies of steatite (7) and the Chumash of the Santa Barbara Islands made whales (8) and stylized pelicans (9), some inlaid with shell.

THE COLUMBIA RIVER area had remarkable carvings: the owl bowl (10) is a fine example.

THE PUEBLO CULTURE used stone animal fetishes ceremonially; some were painted (11) or carved with designs such as the terraced rain cloud on the little bear (12). Zuni hunting charms (13) were carved in animal forms. Human figures are rare, highly conventionalized (14).

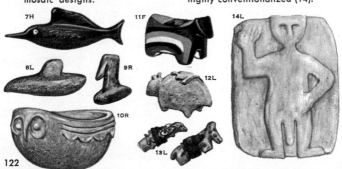

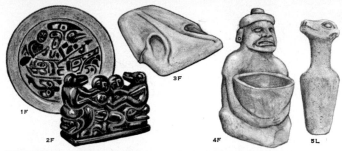

NORTHWEST COAST stonework does not rival the work in wood from the same area. The Haida carved black slate (argillite) into elaborate pipes (p. 121), boxes, plates (1), model totem poles, and complex depictions of myths (2). This slate work has been done since about 1800 to sell to sailors and other visitors. Other stone was used for utilitarian objects. On heavy pile drivers (3) the handholds are often cut to resemble eyes in a face. Small figures (4) with bowls on their laps were used as paint or tobacco mortars, a type which occurs also on the Columbia River. Carved celts (5) often were used ceremonially to kill slaves or break coppers (p. 144).

THE NORTHEAST tribes did no stone carving but excellent knives (8) and spear points (6, 7) of slate and gouges (3-p. 118) of harder stone were made in Maine. Slate points were also made on the Northwest Coast. Ceremonial spuds (9, 10) occur throughout the east.

THE SOUTHEAST AREA produced the finest native stone carving. Human effigies were carved as pipes (p. 120) and pairs of statues (11) were sometimes buried in graves. Some figures are large and realistic (14). Beautifully polished bird effigy bowls (12) and plates (13) engraved with sacred symbols are carved from the hardest stone.

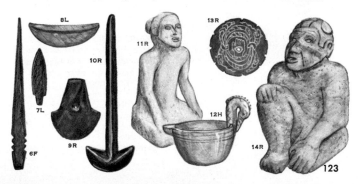

*Mandan
Painted bison skull*

BONE, ANTLER, AND HORN

Valuable by-products of animals hunted for meat and skins were their bones and other nonedible parts. Long ago man found these useful for tools, weapons, and ornaments.

THE LONG BONES of bison, elk, caribou, bear, and deer are thick, dense, and hard and provide excellent material for making slender, pointed tools (p. 125). The small bones of big animals and of many small ones are of varied shapes and sizes and often need little modification for their use.

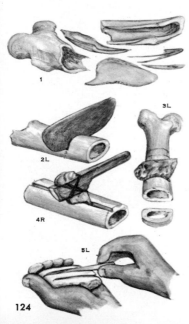

BONE WORKING is often begun by breaking the bone with a rock or hammer. The ends of long bones can be broken off or the bones smashed to make sharp splinters (1).

ABRADING with sandstone (2) is used to smooth rough ends or to cut into the hollow interior.

SAWING with a serrated stone blade (3) is done to remove a section of bone or to make rings or tubes.

GRAVING OR SCORING with a flint point (4-Ingalik) is done to cut across the bone, to split long bones or remove splints of bone or antler.

GRINDING (5) bone is similar to sharpening stone tools (p. 116). Awls, needles, and pins may be brought to fine points on grooved sandstone abraders.

POINTED IMPLEMENTS of bone were used as awls, hair or ear pins, bodkins, daggers, or pottery engravers. Deer shank bones were used with one end intact (1, 2) or split (3). Fibulae (4) and turkey leg bones (5) had only to have the end pointed. The ends of deer tibia (6), the ulna of deer (7) or raccoons (8), and many bird bones (9) made excellent handles. Splinters were pointed (11) or smoothed into spatula shapes (12).

BONE NEEDLES AND PINS are clearly identifiable in some cases. Matting needles were used to make rush stem mats (p. 60). On the Northwest Coast matting needles were triangular in cross section (13). In the Lakes and Northeast areas they were flat, with an eye near the middle. Most were pointed at both ends (14-Ottawa) but some (15-Menomini) at only one.

Smaller needles were used by the Lakes and Northeast tribes for webbing snowshoes (16). Needles with eyes (17) were rare but occur in California and other areas; the penis bone of the raccoon (18) and otter with its natural perforation was often pointed as a needle. Other perforated pins were used as hairpins in California (19) and by the Iroquois (20).

WEAVING TOOLS of bone occur in Southwest ruins; some have serrated ends (21) similar to weaving combs today (p. 67). Many pointed bones have notches (22, 23) near their ends, worn there by use.

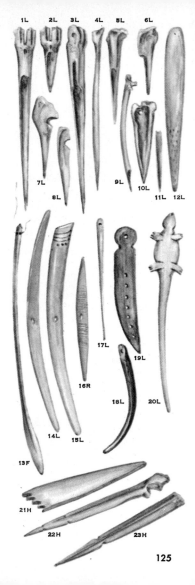

125

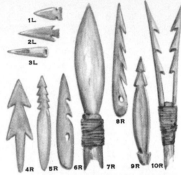

PROJECTILE POINTS AND HARPOONS

were ground from flat fragments of bone (1-Plains, 2-Northeast) or made from shaft sections (3-Iroquois). Spear points were made by the Yurok (4), in Maine (5), by the Iroquois (6), and by the Ingalik of Alaska (7). Some were barbed, detachable harpoon points: (6, 8-Huron, 9-Micmac). The Ingalik and other tribes used barbed bone points for pronged fish spears (10).

TOOLS WITH EDGES AND BITS

include hoes (11, 12), knives (13, 14) and various kinds of scrapers. Bone hoes made from the large, flat shoulder blade of the buffalo (11, 12) were typical of the Prairie area. The bones are very large and the thick spine was cut off before a handle was attached. In Kansas some were socketed (12) as spades or hoes. The flat section of the shoulder blade was easily ground to an edge to make knives (13, 14-Mandan) for cutting skins and roots. Deer and bear scapulae were made into scoops and spoons (15-Menomini). Tools are of many sizes and shapes.

SCRAPERS AND CHISELS

were used for scraping the flesh from skins (p. 77) and for other purposes. Some were small tools to be held between the thumb and fingers and were made from splinters or the toe bone (16) of a bear or dog. The Ingalik used curved pieces of elk bone sharpened at the end (17) to pry bark from birch trees. The ulna of a bear (18)—a very solid bone with a small central opening—provided a chisel. Other bones, with lighter walls, made good scrapers. Deer femora scrapers were decorated (19) with inlay in the Southwest and the Naskapi (20) engraved their tooth-edged scrapers.

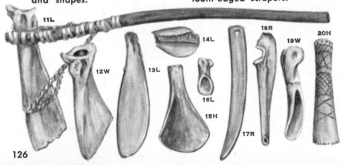

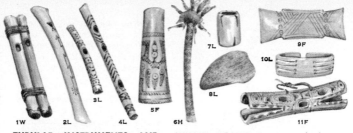

TUBULAR INSTRUMENTS AND ORNAMENTS

of bone are found in all areas. Shafts of long bones, especially of birds, were used for double flutes (1-Hupa) and dance whistles (2-Plains). Many were engraved (3, 4-California). Small tubes with a hole near the center (3) were used by the Pueblos as bird calls. Engraved tubes occur in Hopewell (5) graves, and bird bones decorated with feathers (6) were worn in the ears by the Pomo. They also used polished tubes as dice (7). The most elaborate tubes were abalone inlaid "soul catchers" (11-Tlingit) of the Northwest Coast. Engraved hair ornaments were made by Columbia River tribes (9); bone bracelets (10-Mandan) were worn in the Plains and Southeast. Porous bone (8) served as paint brushes.

WHALE BONES

were worked into implements on the Pacific Coast, particularly by the tribes in the northwest. Whale bones are hard and strong, and the great size of the bones made possible the production of some unique objects.

On the Northwest Coast large flat tools with rounded edges (12, 13) were made for shredding cedar bark. The enormous vertebrae, with the central section hollowed out and the large spinal processes carved or engraved (14) or completely removed (16), were used as tobacco mortars. Heavy helmets (15) were carved in effigy forms. Clubs for war (17) and for killing salmon (18) were carved; smoothly polished daggers (19) were often decorated with effigy carvings.

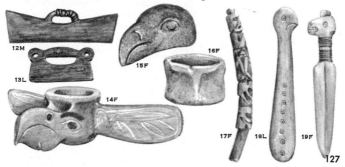

127

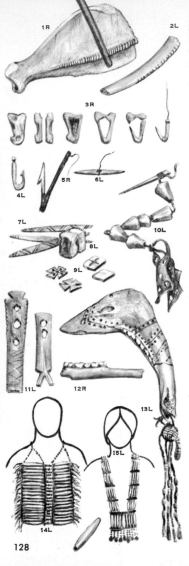

MUSICAL RASPS are simple rhythm instruments that were made by notching the spine of a deer shoulder blade (1) or a rib bone (2). A stick is rattled along the notches.

FISHHOOKS were made in many areas. One type was from a deer toe bone (3) halved and ground down for a hook. Early Northeast tribes made barbed hooks (4) and in California a barbed point was tied to a wood shank (5). Simple gorge hooks (6) were widely used.

GAMES OF CHANCE, using painted counters (7), deer ankle bone dice (8) or marked chips (9) to be thrown from a basket bowl, were widely played. In the "ring and pin" game (10-Winnebago) hollow deer bones were tossed and caught on a bone pin.

SHAFT WRENCHES (11-Arikara) were used to straighten arrows.

UTENSILS for shelling corn (12) were cut from the jaw bones of deer in the Lakes and Southeast areas. Clubs (13-Arikara) were made of bison and horse jaws; teeth were ground down and upright section sharpened.

HAIR PIPES were once made by the Indians for their decorations (p. 144) but the famous breastplates (14) of the Plains men and the long necklaces (15) of the women are from cow bone beads made in eastern factories. Early breastplates (1855-89) were dentalium shells.

Spear throwers (1) gave Archaic hunters more power.

ANTLERS of deer, caribou, and elk are easier to work than bone. They are solid and can be softened by soaking in water. The tines are naturally shaped for projectile points (2).

SPEAR-THROWERS, or atlatls (1), were used by Archaic cultures before bows and arrows. They were weighted (p. 119) and had socketed hooks (3) to fit into the base of the spear.

ANTLER HARPOONS were used on both coasts. A variety of barbed forms were made in California (4, 5, 6). Harpoons with barbs on only one side were used by the Iroquois (7). They also were used on the Northwest Coast (8), and in the Ohio Valley (9).

ANTLER CLUBS (10) from the Northwest Coast are carved from the thick shaft of the elk antler and decorated with abalone inlay and engraving.

ANTLER CELTS AND WEDGES were ground from the thick part of the antler. Curved wedges were used by the Hupa (11) to pry bark from trees. Straight wedges were smoothed for hafting as celts (12, see p. 118). Some had handles (13). In the Plains antlers were split (14).

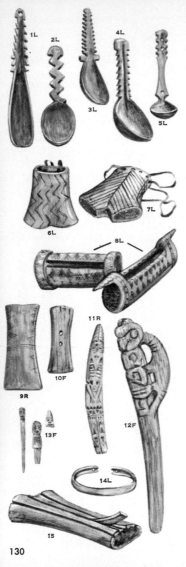

ANTLER SPOONS of a distinct style were carved and decorated by the Yurok and Hupa (1-4). A supply was kept for guests but only men used them to eat acorn meal mush; the women used a mussel shell. Large elk antlers were soaked, cut into slabs, then shaped by grinding. The Lakes tribes occasionally made antler spoons (5).

PURSES made of antler were used by the Hupa and Yurok to hold dentalium shells. One type was made from a forked section of antler (6, 7). Another (8) was hollowed from a heavy section of antler shaft.

NET SPACERS AND HANDLES of elk antler were used in northwestern California. They were similar in shape but the spacers (9) were solid and smooth; cord could be wrapped and slipped off to keep the meshes even in making nets. Handles (10) were perforated to fasten the net cords.

ANTLER FIGURINES (11) which reflect the designs on Wasco baskets (p. 46) and elaborate batons or wands (12-Wishram) were carved on the Columbia River. Hairpins (13-Wasco) were topped with faces and figures.

BRACELETS OF ANTLER (14) were made by the Mandan and other Prairie tribes. The antler strips were made by graving (p. 124) parallel grooves (15). They were engraved, soaked and then bent into shape to form bracelets.

ANTLER ROACH SPREADERS were used by the Lakes and Prairie tribes who wore elaborate headdresses (1). The spreaders, tied on with a lock of hair, secured the roach and spread its fringe. A bone cylinder held a plume. Spreaders of the Lakes area (1-Sauk) are straight, those of the Osage (2) slightly bent.

CARVED ANTLER COMBS were made in several areas. The best known are those of the Iroquois (3, 4), decorated with figures and engraving.

ANTLER LABRETS (5-Ingalik) are worn in the lower lip by the tribes of the northwest.

ANTLER EFFIGY FIGURES appear on awl handles in the Lakes area (6, 7, 8). The Iroquois carved small figurines (9).

ANTLER HANDLES were used for knives (10) and copper celts (p. 142).

TEETH AND CLAWS were used as tools and as decorations. Sea lion teeth were engraved for necklaces and crowns (11) by the Yurok; worn in ceremonial dances. Beaver incisors, engraved by the Salish for dice and hafted as gravers (12-Ingalik) in Alaska and by the prehistoric Northeast tribes, were also included in Yurok crowns. Grizzly bear canines (13) were inlaid with pearls by the Hopewell. Bear claws, prized in the Lakes and Prairie areas for collars, were worn in headdresses (14) by the Tlingit.

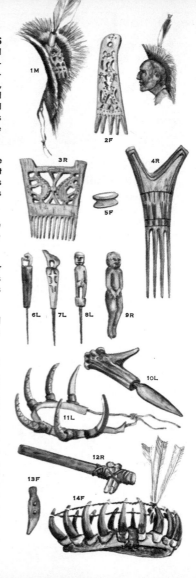

1M 2F 3R 4R 5F 6L 7L 8L 9R 10L 11L 12R 13F 14F

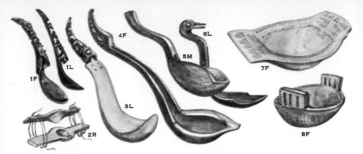

HORNS of bison, goats, sheep, and cattle were soaked to soften them and then shaped into various articles; some were set in wood molds (2). Decoration was added by engraving, carving, and shell inlay.

HORN SPOONS were a specialty of the Northwest Coast. The black, shiny horns of mountain goats were used for small spoons (1) or combined with the amber-colored horn of mountain sheep (3). Sheep horn was also used for large carved spoons (4) here and by the Hopi (5) and some Plains tribes (6).

BOWLS OF MOUNTAIN SHEEP HORN made by the Tlingit (7) are often shaped like animals or birds; those of the Wasco (8) and Salish have square raised ends and geometric designs.

RATTLES OF COW HORN (9) were made by the Iroquois. Bison horn spoons (10) and cups (11) were once common in the Plains.

DEER HOOVES were used as dangles, and on rattles on the Northwest Coast (12) and in the Plains and Prairie areas (13).

TURTLE AND TORTOISE SHELLS were used as bowls (14) and rattles. Iroquois turtle rattles (15) were beaten on a log and box tortoise rattles (16) tied to the ankles of Pueblo dancers.

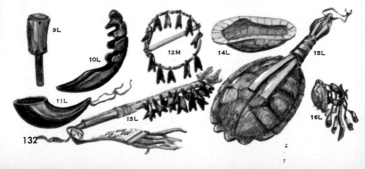

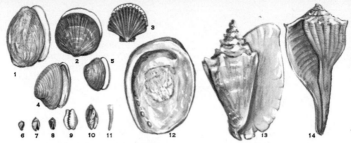

SHELLWORK

Man has used shells for ornaments and tools since the earliest times. Some come from bivalves like mussels (1), scallops (3), and clams (2, 5), which have paired shells; others come from univalves such as the queen conch (13) or whelk (14). Almost every small snail shell (6-Marginella, 7-Olivella) is used for beads or pendants and the iridescent interior of the big abalone shell (Haliotis-12) is treasured for decoration.

Shells were major items in intertribal trade: conchs and whelks were traded from the south Atlantic and Gulf of Mexico north to Canada and west to the Pueblos. Trade routes from the Gulf of California and Mexico brought conus (8), cowrie (9), and oliva (10) shells into the Southwest. On the Pacific Coast dentalium shells (11) were traded for hundreds of miles and abalone reached north to Alaska. In the 19th century traders imported shells for trade with the Indians.

MUSSEL AND CLAM SHELLS are useful and decorative. The Nootka used shells for blades on whaling harpoons (15). In the east they were used for spoons (16), hoes (17), and knives (18). Fishing lures (19) of shell are found in the Lakes area; mussel shells were used by the Yurok to strip iris fibers (20).

133

CLAM SHELL BEADS were made by many tribes. The Pomo made great quantities for use as "money" with the magnesite beads (p. 119). Trips were made to gather shells of the Washington Clam (5-p. 133). The rough exterior was ground off and the shells were broken, roughly shaped (1) and drilled. This was once done with a stone point on a shaft rolled on the leg (2). Later the pump drill was brought in by the Spaniards (p. 117). The rough beads were strung on stiff grass and ground on sandstone slabs (3). Water added to make a paste aided the process.

Beads were woven into girdles (4), inlaid on bone hairpins (6), or sewn on baskets (p. 48). Some were strung in necklaces (7) for gifts and payments. Tubular beads (5) were made from the thick hinge portion.

THE SOUTHWEST tribes traded seashells from the Gulf of California and the Pacific over regular routes. Bivalves such as the Bittersweet Clam (Glycymeris, 2-p. 133) were used for carved bracelets and rings (8, 9) by the prehistoric Hohokam and Mimbres peoples. The centers were ground out to leave only the rims. The Hohokam frogs (8) were carved from the thick hinge. Pendants were cut from the glossy shell in various geometric forms (10, 11-Pueblo) and in the shape of small animals (12-Mimbres) and birds (13-Hohokam). The Zuni still make small animal figures (14) for necklaces.

WAMPUM, made by Iroquois and northeast Algonkian tribes, consisted of white and purple beads (2) ground from the Hard Shell Clam or Quahog (4-p. 133). Strings of wampum (1) were used as money and the Dutch manufactured it soon after settling Manhattan. For years it was mass produced; a small factory in New Jersey made wampum into the 20th century. It was woven into ceremonial belts (3, 4), especially by the Iroquois, and exchanged at peace treaties. Some constituted official tribal records.

RUNTEES (5-7) are distinctive shell disc beads made by the Iroquois and Delaware. They are engraved and perforated with two parallel holes.

PUEBLO NECKLACES (8) of graded small shell discs are made from clam shells imported from the coast or the Gulf of California. Strung with turquoise or coral, they are highly valued.

ETCHED DESIGNS in shell (9) were unique to the Hohokam of southern Arizona. The design was etched with acid solution.

INLAID PENDANTS with designs in turquoise and jet (10) on pecten shells have been made for centuries by the Pueblo. Modern ones (11) are made by the Zuni.

CHUMASH PENDANTS of clam shell (12-14) were made in varied shapes and often decorated with inlay (12) or patterns of indentations (13).

135

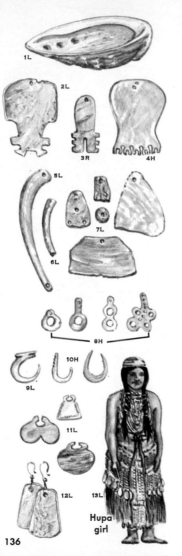

Hupa
girl

UNIVALVES were valued for decoration and ceremonial objects. Abalone a univalve from southern California, was traded to New Mexico and Alaska.

THE CHUMASH used abalone for bowls (1), pendants, and beads. The unique "banjo shaped" pendants (2, 3, 4) are 5 or 6 inches high. Their shape possibly represents dancers. This tribe also made long beads (5), some perforated longitudinally (6), and many simple pendants (7). Complex forms drilled with many holes (8) were made only in this area. Finely polished, semicircular "fishhooks" (9) may be ornaments but other shell forms are probably real fishhooks (10).

NORTHWEST COAST tribes imported abalone for inlay on wood carvings (p. 154) and some was used for pendants to hang from the septum of the nose (11-Kwakiutl).

SOUTHWEST use of abalone was limited to the manufacture of precious pendants and ear decorations (12-Hopi). The Zuni use some in their inlay and channel work on silver (p. 147).

NORTHERN CALIFORNIA tribes, such as the Hupa and Yurok, hung large pendants of abalone from the fringes of women's dance skirts (13). Their front aprons were covered with small shells and they wore many strings of shell beads draped around their necks.

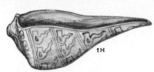

CEREMONIAL VESSELS were made from univalves such as whelks and conchs. The Indians of the Southeast used them for the "black drink" to cause vomiting for ceremonial cleansing. At the great Spiro Mound in Oklahoma many fine shell vessels have been found with engraved designs. Most of the motifs, such as the forked eye (1) and the eagle dance (2, 3) found there, are typical of the Southeast. Eagle dancers and terraced arches (2) are also found in the Southwest among the Pueblos. Rattlesnakes (4) also appear in both areas.

CONCH SHELL TRUMPETS (5) have been found in prehistoric sites in the Southwest and the Southeast. The spire is ground off to make a hole for blowing the instrument. Such horns are still used in the Pueblos and high in the central Andes.

COLUMELLAE are the spiral centers of the large univalves (6). In the Southeast they were ground on the end for scrapers (7) and perforated (8) or grooved (9) for pendants. Knobbed pins (10) were worn in the hair or the ears (11, 12, 13). Columellae beads (14, 15) were most common in the Southeast. Long cylindrical beads (14) were perforated longitudinally; other shapes were made also (15).

137

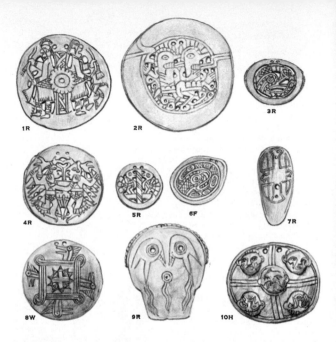

1R 2R 3R 4R 5R 6F 7R 8W 9R 10H

ENGRAVED SHELL GORGETS are associated with the late prehistoric cultures of the Southeast area. Most are circular and formed from the wall of large whelks. They have two marginal holes and were hung around the neck. Fine line designs are engraved in the pearly inner surface of the shell.

Dancers are shown (1, 2, 4) with antler headdresses, anklets, and girdles of shells. The Spiro figures (1) are stiff; those from Etowah and eastern sites (4) are active. One type (2) depicts dancers in a conventionalized flowing style. Such conventionalization occurs also in one type of plumed rattlesnake design (6) in which the eye, mouth, tail, and feathered nose can be seen only by comparing it with the more naturalistic style (3).

Cross designs are common. Bird motifs are found with turkey cocks (5) and woodpecker heads on a looped square (8). A unique gorget from Spiro (10) has carved faces; they show the "weeping eye" design typical of the masks (9) often found in burials. The Iroquois made a few shell gorgets (7), usually decorated with simple designs of interlocking rectangles.

WHOLE SHELL BEADS AND EMBROIDERY are found in almost all areas. Even very small snail shells were strung together or sewn to skin or cloth. Archaeologists have found many graves in which the body was almost covered with small beads. The only remaining example of shell-embroidered clothing is the so-called "Powhatan's Mantle" now in England (1). It is of leather with small marginella (6-p. 133) shells sewn in designs.

COLLARS AND GIRDLES (2) were woven from strands of shells and decorated with conus and cowries (p. 133) by the Pueblo (2) and in northern California. The rows of shells are held in place by fiber twine which forms a netting base looping them together. Large colored conus shells (8-p. 133) were ground down to make rings (3) which were engraved and painted in the Southwest.

NECKLACES of such small shells as olivella (7-p. 133) were common in California (4-Miwok) and the Southeast. The ends of the delicate shells are ground off to make an opening for a cord to be passed through. In the Southeast area small conchs (5) were drilled and hung around the neck with a pendant. Even rather large univalves were used in this manner. Pieces of shell were carved for necklaces as is done today at the Pueblo of Zuni (6). Here small shell birds are often combined with shell beads and turquoise.

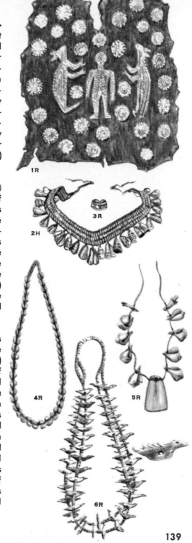

139

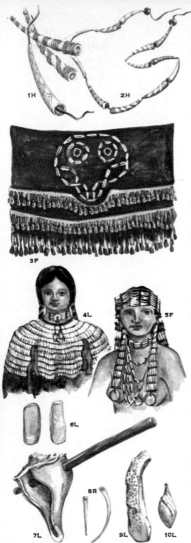

DENTALIUM (11-p. 133), or tusk shell, has a slender, cone-shaped shell, open at each end. Although at least two species occur along the Pacific Coast, tusk shells were gathered only by the Nootka of Vancouver Island and traded south to northern California where the Yurok, Hupa, and Karok regarded them as treasure. They engraved them and wrapped them with snake skin (1). The shells were graded by size and used for money (2).

DENTALIUM EMBROIDERY was done chiefly on the Northwest Coast where the shells were regarded as decoration rather than wealth. Dance aprons (3) and robes had traditional designs.

DENTALIUM DECORATION in the Plains was worn by both men and women. When dentalium shells were brought by the Whites into the northern Plains about 1860 they were called "Iroquois money." They were sewn over the shoulders of women's dresses (4-Sioux) like a cape and worn in chokers with the shell discs from trading posts. Nootka girls (5) wore ceremonial crowns, earrings, and necklaces of dentalium.

SHELL TOOLS were common in the Southeast. Celts (6) were ground from heavy conchs in Florida and whole shells were hafted as picks and hoes (7). Shell needles (8) have been found in the Southwest, and shell chisels (9) and plummets (10) were used by Florida tribes.

METALWORK

Before Europeans came, copper was the only metal worked in North America although bits of meteoritic iron were used and pieces of lead (galena) and silver were prized. When the traders brought iron, the Indians wanted it for tools. They traded furs for silver ornaments and soon discovered how to make their own. Brass kettles were cut up and shaped into many types of tools and trinkets.

COPPER was used for making tools in the Lakes area about 3000 B.C.—the earliest metalwork in the new world. Later the Hopewell people (p. 143) used copper for ornaments, as did the prehistoric Creek and other Southwest tribes (p. 143).

COPPER-WORKING TECHNIQUES in North America were simple. Most copper was found in the Lake Superior region in pure nuggets (1) or dug out of veins in the rock. It was so pure that it could be hammered into shape while still cold. To make it easier to work and less brittle, it was usually heated and chilled while being beaten (2).

In the Southeast, copper plates were grooved by indenting them with a bone or antler tool (3) while the sheet lay on a soft skin. Grooves were made for decoration or as a step in cutting. To cut the plates into forms, the worker reversed the sheets and ground off the ridges with a straight abrading stone (4). The edges were then smoothed and rounded. Molds were not used.

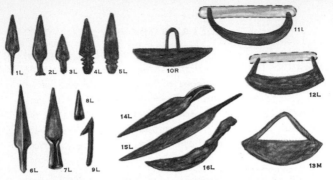

COPPER TOOLS were first made in the New World about 3000 B.C. by the Indians of the Old Copper Culture. They lived in the northern part of the Lakes area where there are deposits of pure copper. Many kinds of tools and weapons were hammered into shape. Stemmed points for spears and arrows (1-5) had long, pointed tangs (1) for insertion in the shaft, or short stems which were bound on like stone points (p. 114). The socketed points (6-8) utilized the qualities of copper and were bent to form collars around the shaft. In some a sheet of copper was simply bent into a cone (8). Barbed points (9) also were made.

KNIVES were made in two basic patterns: one was crescent-shaped (10-13), the other had a handle at the end (14-16). Both kinds were probably used with handles of bone, antler, or wood (see page 131).

CELTS are similar to those made of stone by other people (p. 118). The unique style was the socketed celt (17-19) with a wrap-around collar for insertion of a handle. Antler handles have been found (19) which fit the celts and it is possible that some might have been hafted to use as an adze. Some celts were rectangular (20), others were flared (21) or pointed (22).

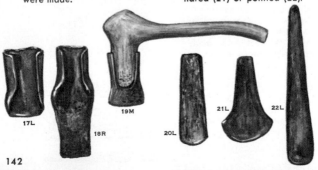

SOUTHEAST COPPER consisted largely of ceremonial plaques made of thin sheets. The raw copper was traded from the north by the Muskogean and Caddoan tribes, probably from A.D. 1200 to 1540. Designs were made by cutting and indenting or repoussé and the sheets were often riveted together. Design motifs were the eagles (1) and eagle-costumed dancers or warriors (2) which appear on shell work (p. 137). The copper head (4) shows the "weeping eye," a copper plume, and the typical ear plugs (5). Beads and pendants (3) were made and thin sheets of copper used to cover wood blades (6).

THE HOPEWELL CULTURE, which flourished in the Ohio Valley from 100 B.C. to A.D. 200, made extensive use of copper, traded from the upper Lakes area, as well as many other exotic materials such as obsidian, sea shells from the coast, grizzly bear teeth from the Rockies, and small amounts of gold and silver. Copper was hammered into large ornaments shaped like snake heads (7), birds (8), fish (9), and double-headed birds (10), usually placed in burials. Headdresses and earrings (11) were made of copper and many copper ornaments (12, 13) were sewn to clothing. Reed pan pipes were held with copper bands (14).

NORTHWEST COAST copper may date back to an early period when it was traded from the Copper River region of Alaska. It was hammered cold into sheets for masks (1) and used to embellish wood carvings (2). Unique plaques (3), called "coppers" (6 to 30 inches), were made of heavy sheets and were of great value in potlatch ceremonies. Each copper was given a name and its history and value were known throughout the area. Crest designs were engraved or painted with black lead. It is probable that all existing coppers were made of rolled sheet copper that was brought in by Europeans.

Sheet copper was hammered into various shapes for rattles (4), and heavy daggers (5) were made in forms similar to earlier weapons of whale bone. Thick copper wire, acquired from trading ships, was twisted into bracelets (6) and collars (7).

THE SOUTHWEST had very little metal before European contact. Small copper bells (8) were made by the early Pueblos and Hohokam by a casting process.

BRASS, an alloy of copper, became available to the Indians only through White trade. It is easily worked and the Navajo beat it into tobacco flasks (9) and bracelets (10, 11). The Lakes and Plains tribes cut up brass pots and rolled the pieces into "hair pipes" (12). Brass, tin, and silver cones were hung from the fringes of bags and clothing (13-Apache).

144

SILVER was never worked extensively by the prehistoric Indians of North America. By 1800, the Iroquois and other tribes in the Northeast were making their own ornaments. The craft spread rapidly to the Lakes and west to the Plains and Prairie people, and influenced the development of silverwork among the Navajo. On the Northwest Coast the Haida and Tlingit became excellent silversmiths and some work was done by the Seminole and Creek in the Southeast.

WORKING SILVER is quite simple and the Indians do many things with it which they could not do with copper. It softens easily with heat and is beaten into sheets from which forms for brooches, buckles, and bracelets can be cut.

Hammering sheet silver into a wood or iron form is done to make hemispherical buttons, bead halves, or rounded plates for belt decorations.

Stamped designs are easily made by tapping an iron die or punch into the soft silver (1). Silver may also be engraved by scratching with an iron awl.

Casting silver is a technique learned from the Europeans or Mexicans. Molds for casting are made in the Southwest by carving designs in fine grained pumice or sandstone (2). A capstone is used to close the mold and the molten silver is poured in (3). When it has cooled the mold is opened (4) and the rough form is removed. The rough edges are filed, the surface is polished, and it is bent into shape (5). Almost all cast silver is made in the Southwest.

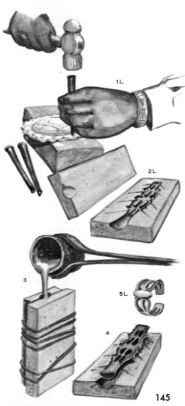

NAVAJO SILVERWORK is one of the most famous crafts of the American Indian. But it is not native to the Navajo nor have they been doing it since prehistoric times. During the first half of the 19th century the Navajo got some brass and copper ornaments (p. 144) by trade or war and learned to work iron from Mexican smiths about 1850.

Not until after their long imprisonment at Fort Sumner did some Navajo men begin to copy Mexican silver techniques and produce the first bracelets and earrings (circa 1870). The first pieces were simply hammered out of American silver dollars; casting (p. 145) was done by 1875. Sparse decoration was applied by engraving and by stamping straight geometric designs with an iron chisel. About 1890 steel dies (p. 145) were copied from Mexican leather workers and used for stamping silver. Forbidden to use dollars, the Navajo turned to Mexican pesos, which contained more silver. Some turquoise was

used, but most early jewelry had no stones and was heavily stamped. About 1900 Navajo silver was commissioned in quantities for sale to tourists.

The Squash Blossom necklace (1) has hollow beads and decorations copied from Spanish and Mexican pomegranate designs. The crescent "najahe" is believed to go back to Moorish designs. The "ketoh" (2), once a bow guard, is often decorated with cast silver. Bracelets are the most popular ornaments; they are cast (3) or cut from a strap of silver (4) and decorated with stamping and pieces of turquoise (4). Powder chargers (6) and tobacco flasks (8) were once utilitarian items. Buckles, cast (5) or hammered and stamped (7), are usually worn with belts studded with silver "conchas" (9). The first conchas were probably copied from silver hair plates (p. 149) of the southern Plains tribes. Brooches (10) are worn by women to decorate velveteen blouses. Some women now are silversmiths.

ZUNI SILVERWORK is the best known and probably the oldest silverwork in the Pueblos. The Zuni learned silver techniques from the Navajo in 1872. Their first pieces were like Navajo, but when they began to use turquoise with silver in 1890 a new style developed. The silver became only a base for the turquoise and every piece was lavishly decorated. The finesse for setting small stones was not attained until the Zuni smiths acquired the tools: emery wheels, fine pliers, drawplates for making silver wire, and rollers to make uniformly thin sheets for fine work.

Clusters of turquoise are set in large bracelets (1), elegant earrings (2), and necklaces (3). Brooches and bracelets depicting kachinas (4), dragonflies, and the Knife Wing God (5) are designed with colored stone and shell. Some is set in mosaic, but channel work, with stone set in silver and polished to a uniform surface in buckles (6) and bracelets (7, 8), is more recent.

HOPI SILVERWORK has a distinctive style although it was originally learned from the Zuni in 1898. For many years it was similar to Navajo work but after World War II a group of ex-servicemen took classes in jewelry making in New Oraibi and the Hopi Silvercraft Guild was created. The Hopi utilized new techniques and created designs from their own tradition.

Forms are usually simple and turquoise is used only for accent or in mosaic with shell. Some designs are derived from traditional pottery motifs (11, 13). Cut-out patterns are typical on brooches (14) and collars (16) and the distinctive "over-lay" (9, 10, 11) is done by cutting a design in a sheet of silver and laying it over another which has been chemically darkened; the darker design shows through the opening. Simple stamping is often used (12) and repoussé patterns decorate men's bow guards (15). In recent years fine silver work has been done at Santo Domingo and other Rio Grande pueblos.

147

IROQUOIS SILVERWORK began about 1800 after the American Revolution ended the trade in silver brooches made by Canadian smiths. Coins and ingots were hammered into sheets and decorated by stamping and rouletting. After 1825 German silver, a hard alloy of copper, zinc, and nickel, was frequently used.

Brooches were common ornaments with curved hearts (1) and double hearts (2), sometimes with crowns (2, 3). Although of Scottish origin, the double heart was called the "Iroquois National Badge" and the heart with crown (3) "Owl" or "Guardian of the Night." Masonic emblems (4) were called "Council Fires." Sunburst designs (5) were typical, and round (6, 7, 8) and square (9, 10) brooches were very popular. Gorgets (11) were made from sheet silver. Earrings with dangles (12) were worn by men and women.

LAKES AREA SILVERWORK probably began when the Oneida, an Iroquois tribe, moved to northeast Wisconsin (1822-27). The Menomini developed a distinctive style, less lacy, with fewer perforations. Circular plates, worn as hair decorations, were engraved (13) or perforated (14) and some were probably worn as brooches. Earrings (15) were simple. Engraved or stamped bracelets (17, 19) were common as were hatbands with real buckles (16). Combs (18) of German silver were still made by the Menomini and other Lake tribes in 1920.

PLAINS SILVERWORK began in the north about 1805. Trade silver was worked until 1850 when German silver, tin, and brass became common. Techniques were punching, filing, and stamping of hammered metal. One popular item was the circular hair plates (1, 2). These may have been copied from the Lakes tribes but were worn by men in a graduated series (1) on a strap attached to the hair. Women wore them hanging from belts. These were the first concha belts, copied by the Navajo about 1870. Early discs had a bar across a center hole (1), later ones had a loop soldered on the back (2). Stamped buckles (3-Cheyenne), broad armbands (4-Cheyenne), large flat crosses (5-Sioux), and silver mounted halters were made throughout the Plains and the Prairie areas. Unique pectorals, or breastplates (6), were hung with crescents like Navajo "najahes." Headbands (7) later became hat bands.

PLAINS PEYOTE SILVERWORK is done mostly in German silver. The jewelry is worn by members of the Native American Church. Indian and Christian symbols are depicted, as in the neckerchief slide (8). Brooches (9) and earrings (10) show birds like the scissor-tailed flycatcher. Men's earrings (11) are distinct from women's (12).

SOUTHEAST SILVERWORK consists of simple brooches and pendants made by the Seminole (13, 14, 15) and Choctaw.

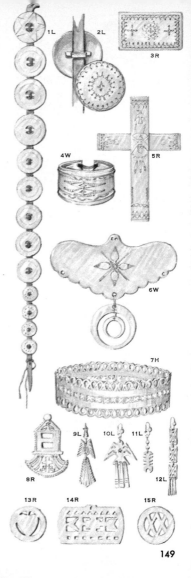

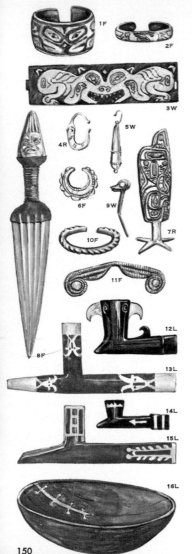

NORTHWEST COAST SILVER-WORK did not begin until about 1865. The most distinctive pieces are broad, thin bracelets (1-3) with typical conventionalized animal designs (1, 3), beautifully engraved in fine lines. Narrow bracelets (2) are less distinctive. Semicircular earrings (4), drop earrings (5), and decorated nose rings (6), were worn by both sexes. Elaborate hair ornaments (7) were worn on ceremonial occasions.

IRON WORKING with meteoritic iron on the Northwest Coast was one of the few instances of iron working in the New World. Small chisels were the chief products. After contact with Europeans the Indians quickly learned to work iron and made fine daggers (8), inlaid hair pins (9), bracelets (10), and a unique hair ornament (11) worn by young girls.

LEAD AND PEWTER were worked in a number of ways. In the Lakes area, crosses were cast in stone molds and lead was used for inlay decoration on pipes. The lead was softened with heat and tapped into designs cut in the stone. Lead pieces were sometimes added, as in the beaks on the bird pipe (12-Chippewa). Inlay was used from the Lakes (14), through the Plains (13-Tonkawa), to the Plateau area. Lead was often combined with inlay of colored stone (15-Chippewa). Precious wood bowls were patched with lead (16), sometimes added for decoration.

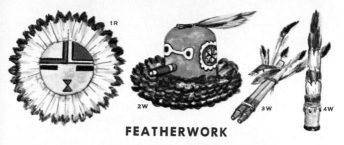

FEATHERWORK

Feathers and Indians are linked together in fiction and in reality. The flowing war bonnet (p. 152) of the Plains has become the symbol of the American Indian. Some birds were regarded as sacred messengers of the gods and their feathers were used as offerings and as decorations for ceremonial costumes and regalia.

SOUTHWEST featherwork is ceremonial. Colored plumes and down are used to decorate kachinas (p. 101) and masks (p. 79). The Hopi Sun Kachina mask (1) wears a halo of eagle feathers and the Zuni Warrior Kachina (2) has a feather ruff. Feather prayer sticks (3, 4) were placed on altars. Eagles were kept for plumes, turkeys were domesticated, and macaw feathers imported from Mexico.

THE EASTERN INDIANS undoubtedly invented the feather headdress which developed later in the Plains. In the Southeast, downy egret plumes and stuffed eagle heads (5) were worn by chiefs and warriors, and feather cloaks or mantles are described by many early explorers. The headband of stiff tail and wing feathers (6-Penobscot) was used by Algonkian and other peoples from Virginia to the St. Lawrence. Topknots, mounted on caps (7), were worn by the Iroquois.

151

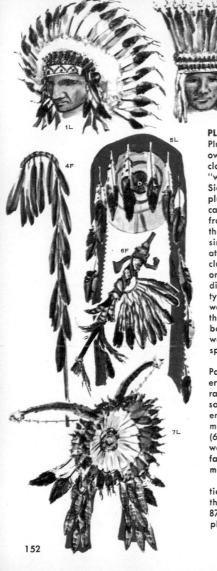

PLAINS featherwork is lavish. Plumes of eagles, hawks, and owls decorated weapons and clothing. The classic feather "war bonnet" of this area (1-Sioux) consists of matched eagle plumes fastened loosely to a cap with a decorated band in front and ermine or ribbons on the sides. Some bonnets had single or double trailers. Except at ceremonials most men, including chiefs, wore only one or two feathers in positions indicating their war exploits. The typical Blackfeet headdress (2) was an upright crown similar to that of the east. Many horned bonnets (3-Blackfeet, also p. 85) were worn, often decorated with split feathers.

Spears and dance wands (4-Pawnee) were elaborately feathered. The buckskin covers for rawhide shields (p. 78) were sometimes decorated with feathered trailers (5-Wichita); ceremonial wands called calumets (6-Pawnee) and some pipe stems were decorated with feather fans, woodpecker scalps, and mallard heads.

Dance bustles (7-Sioux), which tied around the waist, began in the east as ceremonial belts (p. 87). A common type has two plumes and a central rosette.

152

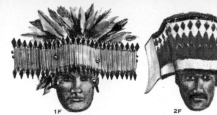

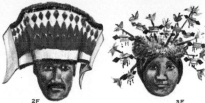

1F

2F

3F

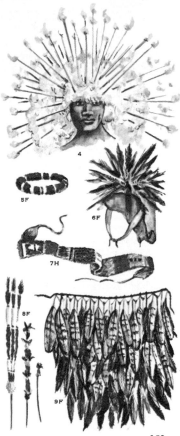

CALIFORNIA featherwork is less flamboyant than Plains featherwork and more sophisticated in design. Dance costumes were decorated with many small feathers in a mosaic-like effect.

Headdresses made of golden quills of flicker feathers (1) mounted on deerskin bands were common from the Hupa to the Pomo. Dark pointed tail feathers gave them serrated edges. The Hupa and Yurok also made a glistening red crown (2) by sewing fifty woodpecker scalps to a deerskin strip for the "Jumping" dance. Pomo women wore a crown of fur (3) with beaded ornaments of flicker feather quills. An elaborate headdress with slender rods tipped with down or poppies (4) was worn in central California for the "world renewal" rites.

The Pomo and other tribes also wore feather-covered coronets (5) and topknots (6) which were usually of dark raven or condor feathers. They were often added to other headdresses. Feathered belts (7) were made by the Pomo. Darts or "tremblers" (8) were made in many colors and worn in the hair or carried in dances. Skirts and mantles of turkey feathers (9) were worn by the Pomo and Mission tribes.

4

5F

6F

7H

8F

9F

153

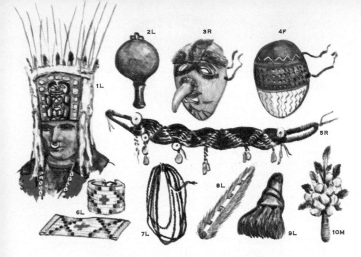

MISCELLANEOUS MATERIALS

The Indians used almost every available material—with greater skill in some areas than in others. Almost every area developed one particular material well.

SEA LION WHISKERS, wood, abalone shell, ermine furs and flicker feathers were combined in the chiefs' headdresses of the Northwest Coast (1). In several areas gourds were used as bottles and rattles (2-Iroquois). Gourds were used by the Cherokee for masks (3) and the Pima used the same material (4) with quite different results. Bison hair was used at an early time in the Lakes and Prairie areas to weave bags and sashes (p. 61). Human hair was used for snares in California and the Shasta women wore belts (5) of twisted horsehair.

The Hopi decorated buckskin dance anklets (6) with quills, horsehair or cotton yarn. Horsehair was also twisted and braided into ropes (7-Pawnee) and bridles by the Apache and some Prairie tribes. Hair brushes were made out of porcupine tails (8) in the Plains and Lakes areas. In California the Pomo and their neighbors made brushes out of soaproot splints (9) for their hair and to sweep acorn meal in and out of baskets. Rattles made of stiff paper-like cocoons (10) were tied around the legs or on a stick in the Southwest and California.

154

SPECIMENS ILLUSTRATED: THEIR PRESENT LOCATIONS

The small letter after the number of the picture indicates the museum or collection of the specimen according to the following key: F—Field Museum of Natural History, Chicago; H—Museum of the American Indian—Heye Foundation, New York City; L—Logan Museum of Anthropology, Beloit College, Wis.; M—Milwaukee Public Museum; W—U.S. National Museum, Washington, D.C. R—indicates the location is given in the list below.

INDEX

G